S0-AGF-436

THE PRISONS

THE PRISONS

[LE CARCERI]

BY

GIOVANNI BATTISTA
PIRANESI

THE COMPLETE FIRST AND SECOND STATES

With a new Introduction by

PHILIP HOFER

DOVER PUBLICATIONS, INC., NEW YORK

Copyright © 1973 by Dover Publications, Inc.
All rights reserved under Pan American and International
Copyright Conventions.

Published in Canada by General Publishing Company,
Ltd., 30 Lesmill Road, Don Mills, Toronto, Ontario.
Published in the United Kingdom by Constable and Com-
pany, Ltd., 10 Orange Street, London WC 2.

This Dover edition, first published in 1973, reproduces in
their entirety—at 60 per cent of original size—the first and
second states of *Invenzioni Capric di Carceri* by Giovanni
Battista Piranesi. The first state, containing 14 etchings, was
originally published in Rome, circa 1745. The second, con-
taining 16 etchings, was originally issued in 1761.
This edition also contains a new Introduction by Philip
Hofer.

International Standard Book Number: 0-486-21540-7
Library of Congress Catalog Card Number: 72-92762

Manufactured in the United States of America
Dover Publications, Inc.
180 Varick Street
New York, N. Y. 10014

PUBLISHER'S NOTE

To our knowledge, the reproductions of Piranesi's *Carceri* etchings in this volume are among the finest ever achieved in the field of commercial book publication. It is our pleasure to record here our great debt to several helpful and knowledgeable people whose interest and cooperation over a period of many months are in large measure responsible for this happy result.

The extraordinary clarity of the illustrations derives from the fact that the photo-offset plates were made directly from mint copies of original prints, mostly from the Lessing J. Rosenwald Collection of the National Gallery of Art in Washington, D.C. Mr. Rosenwald's lively personal interest in this project has been an inspiration to everyone else. At the National Gallery, Miss Kathleen T. Hunt and Dr. H. Diane Russell went to great lengths to facilitate the loan of the prints, and Mr. Fred Cain devoted many hours of his professional skill to the benefit of the project.

We are also greatly indebted to the Fogg Art Museum at Harvard University for lending original art in their collection, and to Miss Ruth S. Magurn, Curator of Prints, who aided us enthusiastically even though she was tremendously involved in extensive renovations to her print room.

The illustrations and text for this volume were photographed and printed by The Murray Printing Company at Forge Village, Massachusetts.

Finally, we wish again to express our gratitude to Dr. Philip Hofer, not only for his excellent Introduction, but also for his keen interest and enthusiasm which over a period of many years have provided the initial motivation for many projects.

Original prints of Piranesi's *Carceri* etchings measure approximately 16 by 21 inches; the reproductions in the present volume are at 60 per cent of original size.

<div align="right">Dover Publications, Inc.</div>

INTRODUCTION

After a truly significant artist dies, although he is often temporarily "forgotten," it is only a question of time before he is rediscovered. Meanwhile, whether adequately appreciated in his own lifetime or not, there is normally a tendency for him to be superseded in the public eye, at least, by some newer figure. Only a few artists in all history have been at once, and continually, recognized. And not even the greatest are internationally acknowledged until they have become established in the general consciousness as great innovators, or as outstanding figures in their national environment.

Giovanni Battista Piranesi (1720–1778) did enjoy a considerable reputation in his lifetime, but—an unusual circumstance—it was mainly *outside* of his native land, Italy! His dramatic personality and technical ability should have inspired nearly as wide attention as did Goya's. But unlike the slightly later Spanish master, who became preeminent in a number of artistic media, with a wide range of arresting, attractive subject matter, Piranesi excelled only in drawing and in the making of architectural prints, which often appeared in very large, expensive books. His most longed-for career—to be employed as an architect—wholly eluded him except during two years in the mid-1760's. This was his great personal tragedy, for it seems clear that he might have become as outstanding in this profession as he desired to be. Precocious, where Goya was late in reaching maturity, Piranesi might be said to have worn himself out prematurely, for he died at 58. Nevertheless, his production of prints was enormous—well over a thousand etchings, mainly large in scale—and his resourcefulness in getting them published, together with his quite controversial archaeological theories, was amazing considering his continual poverty and his unfortunate lack of powerful Italian patrons.

The series of prints which is the subject of this essay was first given the rather formidable, and poorly spelled, Italian title "Invenzioni Capric di Carceri all Acqua Forte Datte in Luce da Giovani Buzard [somewhat later spelled correctly Bouchard] in Roma Mercant(e) al Corso" by their publisher, who was a Frenchman. When Piranesi himself expanded the series to sixteen etchings, and took over the publication some years later, it was not a great deal clearer. One cannot be quite certain that "Carceri" is preceded by the article "Le," and then follows "D'Invenzione de G Battista Piranesi Archit Vene," rather pathetically pointing to his Venetian origin and his aspiration to be regarded primarily as an architect. In neither case, be it noted, is there a date, but we feel rather certain now that the first fourteen prints were conceived and executed between about 1743 and 1745, while Piranesi was in his early twenties. In some respects their author's genius never surpassed this early tour de force, which of course is the reason one can say he was decidedly precocious. Time, and a great need for simplification, has reduced most references to the series to *Le Carceri* (in Italian) and *The Prisons* (in English).

Piranesi's sources of inspiration are not hard to discover. Moreover, as so often in the case of a needy and sensitive artist, they were chosen because

they related to a very deep spiritual conflict. Young as he was, Giovanni Battista had already begun to realize his architectural talents were not wanted. So, like Goya, whose first important print series *Los Caprichos* reflects another kind of inner crisis, Piranesi was not able to hide the fact that his prints are not mere "caprices," but a personal identification with the profounder implications of the subject matter. He had no solid career as a court painter behind him as Goya did. Indeed, because of his intransigent nature and constant quarrels, Piranesi was destined to continual disappointment, which was only lifted for a short time (in 1764-65) when two great ecclesiastical patrons gave him a minor architectural commission. Goya's later career was quite different, for he eventually had his fill of patronage and praise. But toward the end of his life, he abandoned it all and went to live in self-imposed exile. Had Piranesi been given a proper invitation to go to England, he might have prospered there, for a number of traveling English art connoisseurs on the Grand Tour came to admire him. And the contemporary Scots artist and architect Robert Adam became his close friend. A later generation of British notables, including William Beckford and J. M. W. Turner, actually made him famous. So in England, Piranesi was never completely forgotten. In America, his reputation has come much later—mainly, one might say, in the last thirty years.

Although Arthur Samuel's *Piranesi* (London, 1910) was the first critical recognition of this century, Albert Giesecke published a more important work, the first sound biography, at Leipzig one year later. These are the two books that really initiated the rediscovery of Piranesi's genius, which had been largely forgotten during the second half of the nineteenth century. They were soon followed by Henri Focillon's excellent and reliable catalogue (Paris, 1918), and then by Arthur M. Hind's more detailed one which appeared in London in 1922.

From 1922 until after World War II there was a "generation gap" so far as important contributions to the study of Piranesi are concerned. Then came the Pierpont Morgan Library's sensational exhibition of drawings early in 1949. For this an excellent catalogue was written by Felice Staempfle, describing 133 Piranesi drawings for the first time—probably the largest collection owned by any single public institution in the world. And that same year saw the challenging essays by Aldous Huxley and Jean Adhémar solely devoted to the *Prisons* series, with the best reproductions to date of the etchings, printed by the Trianon Press in Paris, but issued at Los Angeles. A. Hyatt Mayor's brilliant short analysis of the artist and his work was published in New York in 1952, quickly followed by Hylton Thomas' important study on Piranesi drawings located mainly in collections outside New York. This last-named volume, issued in London in 1954, was the result of a doctoral thesis presented to Harvard University in 1949 and expanded during several years of European travel. In 1958 at Zurich, Ulya Vogt-Goknil published a very thorough study of the *Prisons* etchings. In the winter of 1962, *The Art Quarterly* contained an exceedingly good article by Patricia May Seklar on the *Prisons* etchings and their related drawings, which was also based on study at Harvard.

More recently, there have been significant further additions to the critical study of Piranesi because by now a reappraisal of the artist's importance is in full swing everywhere in the Western world—most noticeably in the art market. At Paris, in 1969, came the first accurate printing (in *Nouvelles de l'Estampe* No. 5) of J. G. Legrand's pioneering *Notice historique sur la vie et les oeuvres de G. B. Piranesi,* compiled in 1801 with the aid of the artist's two sons and of a (now lost) manuscript autobiography. Finally, Professor Andrew Robison's preliminary report on a larger study in progress was published in the *Princeton University Chronicle* (Spring 1970); this contains much interesting and new information on the printing of all Piranesi's plates.

To be sure, if the artist's own manuscript autobiography, or the manuscript biography by his sons (lost in England sometime after 1831) "ever come

to light," as Hyatt Mayor says, "they will supersede much that has been print-ed about him," and, as G. L. Bianconi suggests in the very first Piranesi biog-raphy (1779) just a year after the artist died, "if all could be told [of Piranesi's life] it would make a story as tumultuous as Benvenuto Cellini's."

One important point should be noticed in relation to this abbreviated ac-count of the literature on our artist. That is the fact that only the first work, Bianconi's, is due to an Italian. All the other important studies were made by scholars of other nations. Piranesi has been still relatively without honor in his own country!

In 1910, Arthur Samuel drew attention to a baroque print which bears a striking resemblance to all of the Piranesi *Prison* series etchings. This is "La Prison d'Amadis," a stage design by the much earlier French decorator Daniel Marot. This may be a direct source of the designs. If not, then surely some of the many stage designs by members of the gifted Bibiena family of artists made during the first decades of the eighteenth century, are. Piranesi must have known them, since "prison" scenes were widely used in Italy for operas, as well as plays, while he grew up. But we should not regard his own *Prison* etchings as any the less significant. They are more powerful, more imagina-tive and more luminous than any of their prototypes. All artists "steal" ideas, great artists like Goya and Piranesi appropriated them frequently and freely, quite certain that their own compositions went well beyond those that may have inspired them.

In 1740, when Piranesi was barely twenty years old, Giuseppe Galli Bi-biena's remarkable book *Architetture e Prospettive* began to appear at Augs-burg (Bavaria) in a series of fascicles, many copies of which were sent to Venice and Rome for the Italian market. International art relationships were as close then as they are now—perhaps even closer, since the art world was so much smaller. Piranesi knew the work of the young French academicians in Rome; he had an atelier of his own near them. The French Academy itself had a good collection of both the Italian and French contemporaries and fore-runners. There he may well have found Daniel Marot's "Prison d'Amadis." The first prison subject Piranesi ever did was probably a rather routine exper-iment in his *Prima Parte di Architetture e Prospettive* in 1743, the very title of which is obviously inspired by Bibiena's slightly earlier work of 1740. And there is another plate in Piranesi's book which he quite unabashedly copied from his compatriot Marco Ricci!

Also, according to Legrand, Piranesi gained an insight into the value of rapid draughtsmanship from such French Academy students as Clérisseau and Subleyras, with whom it is known that he exchanged visits. Nevertheless, as Jean Adhémar says, "his method of work is very much his own. He [usual-ly] would outline his ideas in red chalk . . . and then go over them with pen or pencil. He told Hubert Robert [one of the best French Academy draughts-men], who did not understand this manner of working, 'The completed draw-ing may not be on the paper, I agree, but *it is in my head, and you will see it on the plate!'*"

Piranesi's preliminary sketches, some of which are reproduced in this vol-ume, should be looked at with this quotation in mind. But one must not regard it as a description of the artist's invariable method; like all facile and able draughtsmen, Piranesi varied his technique just as he also varied the graphic media that he used. In the Morgan Library collection there are drawings in pen and brown ink, in black and in red chalk, in ink over chalk of either color, in India ink wash, in pencil only, and in a few colored washes. Nor does there seem to be any particular sequence, chronologically, in which he tended to employ different techniques. The drawings were not for sale; they were a means to an end—not an end in themselves.

Thanks to Miss Seklar's study of Piranesi drawings for the *Prison* series, we can see the fairly close relationship which exists between a drawing (Fig.

1) at the Hamburg Kunsthalle and Plate VIII. (No drawings preliminary to
Plates I to VII, inclusive, are recorded.) Indeed, with the exception of the fact
that the direction of staircases, banners, ladders and masonry has been re-
versed—as is natural when a drawing is copied on, or transferred to, a copper-
plate—the drawing and Plate VIII are very close in every respect. It would ap-
pear that the artist, in this case, was more than usually satisfied by this pre-
liminary version. Actually, he simplified the print slightly. The British Mu-
seum study for Plate XI (Fig. 2) is more remote, yet it, again, is reversed and
simplified. A large beam, ropes and a hanging lantern have been added to the
foreground as that appears etched in the first state of the print.

The drawing for Plate XII, in Madrid's Biblioteca Nacional, is closer again
to the print, the composition of which is only strengthened, little altered, for
the second edition. Finally, the drawing for Plate XIV (Fig. 3), in the British
Museum, is moderately related, whereas other drawings in the British Museum,
Hamburg Kunsthalle, National Gallery of Edinburgh, Courtauld Institute, Na-
tional Gallery of Canada and Morgan Library are more remote, or not related
at all, except that the scenes seem to be prisons, or have architectural features
that recall prominent features in the *Prison* prints. Piranesi was always,

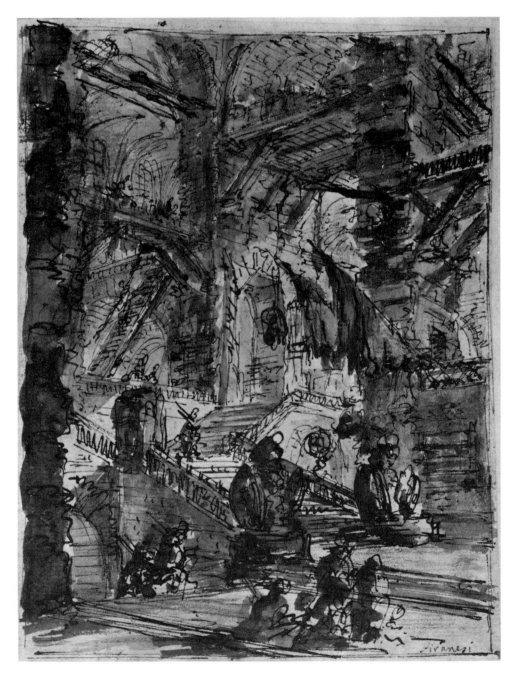

Fig. 1. Preliminary drawing for Plate VIII (Courtesy Kunsthalle, Hamburg).

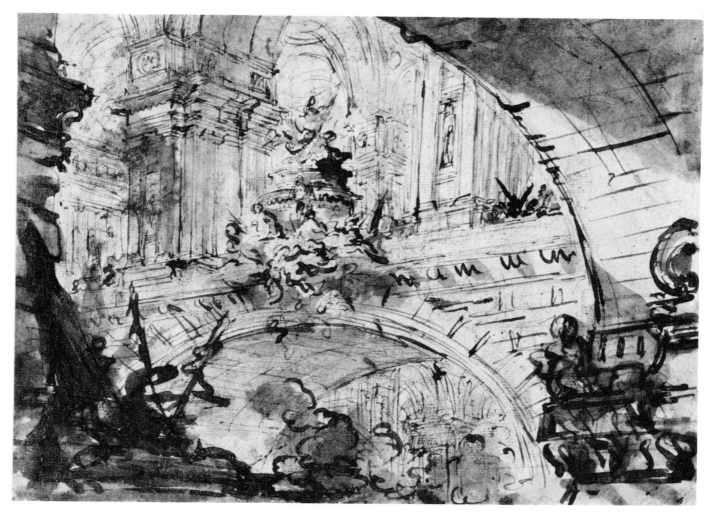

Fig. 2. Preliminary drawing for Plate XI (Courtesy The Trustees of the British Museum).

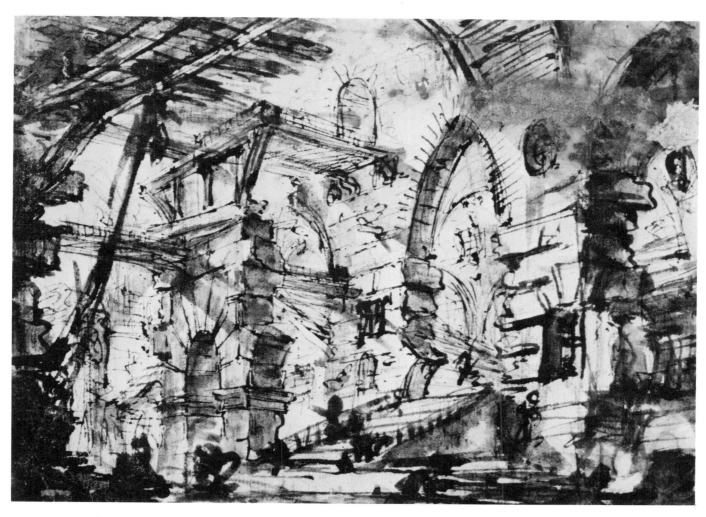

Fig. 3. Preliminary drawing for Plate XIV (Courtesy The Trustees of the British Museum).

throughout his life, fascinated by vast vaulted interiors, suggested to him by the classical period Roman baths, palaces, cisterns and ruined basilicas. It would be a mistake to try to relate drawings and prints too closely, unless the connection is unmistakable, since we do not yet know much about his exact sequence of work. It is tantalizing to wonder what became of a group of supposed *Prison* studies that Hylton Thomas reports "were offered on the art market a few years before 1954." Will they ever turn up again, as many other drawings have done in the past forty years?

The first issue of Piranesi's *Prisons* etchings (ca. 1745) consisted of only fourteen* subjects very lightly bitten by the acid, which are larger, more atmospheric and freer than the print by Marot and most of the prints and drawings for stage designs by the members of the Bibiena family of artists. But, apparently, the Italian art-buying public was not impressed—or else the publisher, Jean Bouchard, failed to promote them properly. (We have already noted that even their title, probably suggested by him, was badly spelled by the artist on the title page.) A. M. Hind's 1922 catalogue guessed that fewer than a dozen complete sets of this first printing still existed. And of these, he said, only a still smaller number had the first version of the title with Bouchard's name spelled "Buzard." Now we know today that Hind underestimated the number of sets still extant, some of which were hidden away unrecognized and unlisted in town libraries, country homes and public institutions. More sets have appeared in subsequent years, but still no very great number. Therefore, one can still say that "first states" of the *Prisons* are quite rare, and that they will never be frequently encountered.

Nearly all art critics agree that the influence of the great Venetian artist Giovanni Battista Tiepolo can be seen in the style of Piranesi's early prints, and it is generally presumed that the young artist must have seen Tiepolo's famous paintings in his Venetian boyhood. Yet it is amazing how individual Piranesi's touch is, nonetheless. His etching is as he intended it to be, almost freehand drawing seemingly made in a passionate hurry. Arthur Hind admires the first edition profoundly, as do many of today's artists and critics, because of a linear brilliance and an abstract quality in keeping with current taste, which also has sometimes been accused of being "the cult of the unfinished"! In any event, the high quality of each of the fourteen first subjects in their "unfinished" (?) state is incontestable. Piranesi's etched lines dance and soar, stimulating the beholder's imagination at the same time that they fill him with wonder, a deep sadness and a sense of mystery. Where do those immense vaults actually end? To what further fastnesses do the innumerable staircases and balconies lead? What tortures are suggested by the projecting beams, wheels, ropes, chains and less clearly defined means of punishment? Who are those wretched beings one occasionally glimpses chained and fastened to the great rings in the walls? By whose authority were they put there, and for what cause? For all Piranesi's barely outlined and emaciated, ragged figure subjects defy analysis, although many of them can be seen to gesticulate or writhe in an agony of suffering. They usually serve to accentuate the scale of the prisons themselves, but they vary greatly in size, and can sometimes be accused of being out of all reasonable proportion. The flags, ladders, pulleys, trophies and lamps appear and disappear at random, but with telling dramatic impact. The group of huge bound figures in the left foreground of Plate X contains the most nearly identifiable victims, but they seem more giants than men, as do the heads on the wall bearing huge rings in their mouths in Plate XV. These have sometimes been called lions' heads. Only in a few of the first plates of the series is there a sense of space extending finally, as in a great ruin, to the out-of-doors. All the subsequent compositions are enclosed deeply and, in the second edition, darkly. No practical architect could possibly have made constructions such as these stand, let alone survive, which

*There are sixteen plates in the second state. No first-state versions exist for Plates II and V.

may be one of the many reasons Italian patrons had for rejecting the young Piranesi's pretense of being an architect. But as prints these edifices are the more powerfully suggestive for being so impossible. There is also a sense of spiritual and physical suffering that is almost an equivalent of hell. Altogether, these fourteen prints, in the first edition of Piranesi's *Prisons,* are more startlingly original than first meets the eye if one already knows the work of the Bibienas. For no previous etcher or draughtsman had ever created anything quite like them as an expression of the prisoner's soul in torment.

Some fifteen years later than Bouchard's first edition of the etched plates, Piranesi reverted to the theme for a second time. He had recovered possession of the plates and, about 1760, began to rework them, determined on this occasion to publish them himself. He apparently felt that, strengthened and elaborated, they would attract the larger audience by that time purchasing his large views of Rome (*Le Vedute di Roma*), which he had begun at about the same time the *Prisons* were first published, and continued to issue until his death. For even today the *Views of Rome* are the most popular and well known of all his various works. In addition, Piranesi made alterations in the plates for the sake of clarification. A first-rate scholar, Andrew Robison, is now studying the continuous changes that took place within Piranesi's own edition (the second) of 1761. Different copies of this series differ in many details. Like Rembrandt and Goya, the artist hardly ever ceased to experiment and to correct. The color of the ink he used varied, as did the power applied in obtaining an impression of each plate. Needless to say, there are a great many more copies of the second edition; for Andrew Robison believes that judging from the various sets he has personally examined, the second states of the *Prisons* were not simply printed and done with in 1761, but were revised and reissued from time to time up to the middle of the 1770's. They also are to be found bound up with other books and prints by the artist. Robison is also seeking to establish a sequence of composition, which is a subject Miss Seklar treats at length, but inconclusively in the eyes of this writer. Andrew Robison has already discovered fascinating variations in printing including retouches dabbed on by hand. Henri Focillon disagreed with Arthur Hind's aesthetic preference for the earlier uncomplicated states of the plates. He greatly favored the later ones, to which he says he found "nothing in the history of etching that is comparable."

There are sixteen plates in Piranesi's second edition, and the two new ones, which definitely seem like late ones (done in 1760?), were inserted as numbers II and V. They were, therefore, not put in at the end as one would perhaps have expected, and one wonders why. The two added plates have a strong relationship, not only in technique, but in a particular variety and complication of subject matter. Why, then, were they not placed *next* to each other? They are not conceived in the luminous, less elaborate spirit of the fourteen original subjects; they show a real connection with the views of Rome. And to some eyes, even if not to Focillon's, they are slightly inferior. No preliminary drawings for these two plates are known to exist. Elaborate bas-reliefs of classical inspiration stand out prominently. In this respect, as in certain other details, they show some connection with Piranesi's four etchings of "Grotesques" (*Grotteschi*), which are a fascinating jumble of classical material, without any likely relationship to actual ruins, that Piranesi conceived and organized into a decorative scheme in the later 1740's.

If it is granted that Plates II and V are the least exciting of the sixteen final *Prisons* subjects, which are the most exciting? No doubt, on this score, there may be much difference of opinion. Plate I, the title page, which Miss Seklar believes was the last one Piranesi originally prepared, designed as it is to tie the series of prints together, is a lovely, relatively uncomplicated subject in the first state, badly lettered and spelled though it is. In the second edition, Piranesi has elaborated it with a large torture wheel, additional beams

and several new balconies, which results in the shortened title wording being less prominent. This was not a result one would have expected from him, but perhaps (if he did the lettering last) he simply found that there was no more room. Plate III is little altered, only darkened, as is also true of Plates VIII, IX, X and XII. The other plates (besides the new Plates II and V) are all more elaborate, as well as darker and stronger. Luminous, almost ethereal, passages in Plates IV and VII are nearly obliterated, but Plates VII, XI, XIII and XIV are given more menacing features. Plate XVI, the last one, has been startlingly altered and given the rather excessive elaboration to be found in the new plates, II and V, added at this same later date. If the writer of this introduction were given a choice, based on purely personal and aesthetic preferences, he would perhaps choose Plate IV among the vertical subjects and Plate X among the horizontal to represent the finest qualities to be found in the whole series. In both these plates, the two states seem nearly equally effective—for different reasons.

It is not usually noticed that the first nine prints of the 1761 (second) edition of the *Prisons* are vertical in format, while the last seven are horizontal. Given the numbering—or sequence when there are no numbers, as in the earlier printings—there is no apparent reason for this sudden shift in compositional emphasis. The first fourteen prints, from ca. 1745, were evenly divided between the two formats, vertical and horizontal—seven of each—whereas the second edition has nine vertical and only seven horizontal, due to the addition of Plates II and V (almost surely later plates). What was the reason? Was this intended or did it just happen? An advantage of such diversity of format is that the framed prints would fit into wall spaces of varying heights and widths, in various combinations. Or perhaps—considering the first edition alone—the first group was intended to be hung directly above the second? Laid out in this fashion, they look well enough, symmetrically considered, but there seems to be no other obvious relationship.

From 1761 to 1778, when Piranesi died, he seems to have concentrated his print making—the chief means of his livelihood—on more practical and popular subjects, even though he could not avoid embarking on a few huge and controversial archaeological works and theses. After his *Views of Rome,* his more appreciated graphic works were concerned with design and decoration, including a large work on vases, candelabras, tripods, lighting fixtures and other attractive antiques which is, in some ways, a sales brochure for objects in which he may well have had a financial interest. Consequently, his last years, while still creative, were hardly happier than his early ones, except that it was in this period that he was given his one important architectural commission—the designs for the restoration of the church of Santa Maria Aventina —by Pope Clement XIII and his nephew, Cardinal Rezzonico (1764-65). At Piranesi's death, his sons carried on the issuing of prints and books and the sale of objects, adding a little (of inferior inspiration) which was their own.

Philip Hofer

I

Title page to "Invenzioni Capric di Carceri."

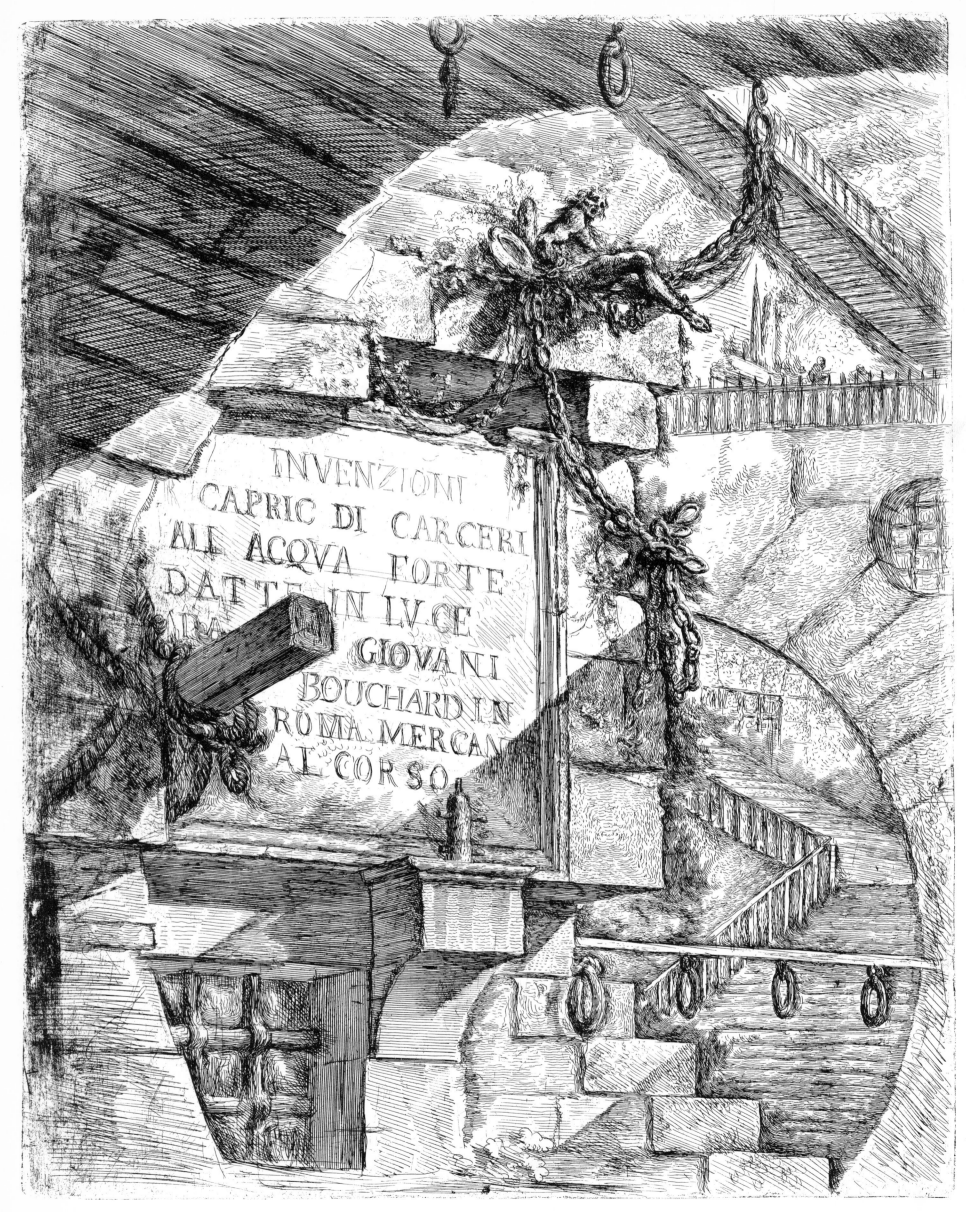

The text within the illustration reads:

INVENZIONI
CAPRIC DI CARCERI
ALE ACQVA FORTE
DATTE IN LVCE
DA GIOVANI
BOUCHARD IN
ROMA MERCAN
AL CORSO

First State.

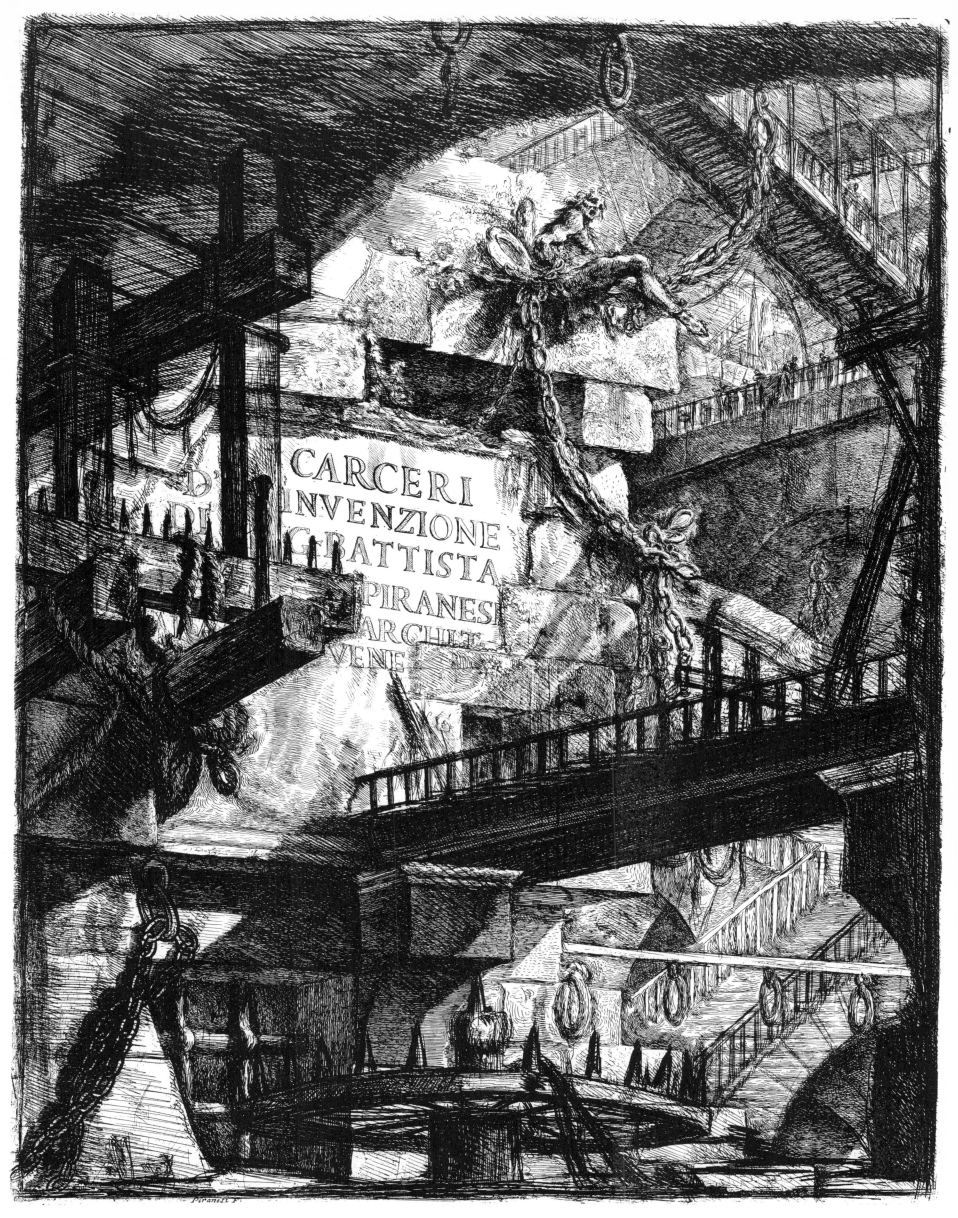

Second State.

II

Carcere, with a Large Number of Human and Sculptured Figures.

No first-state version exists for Plate II.

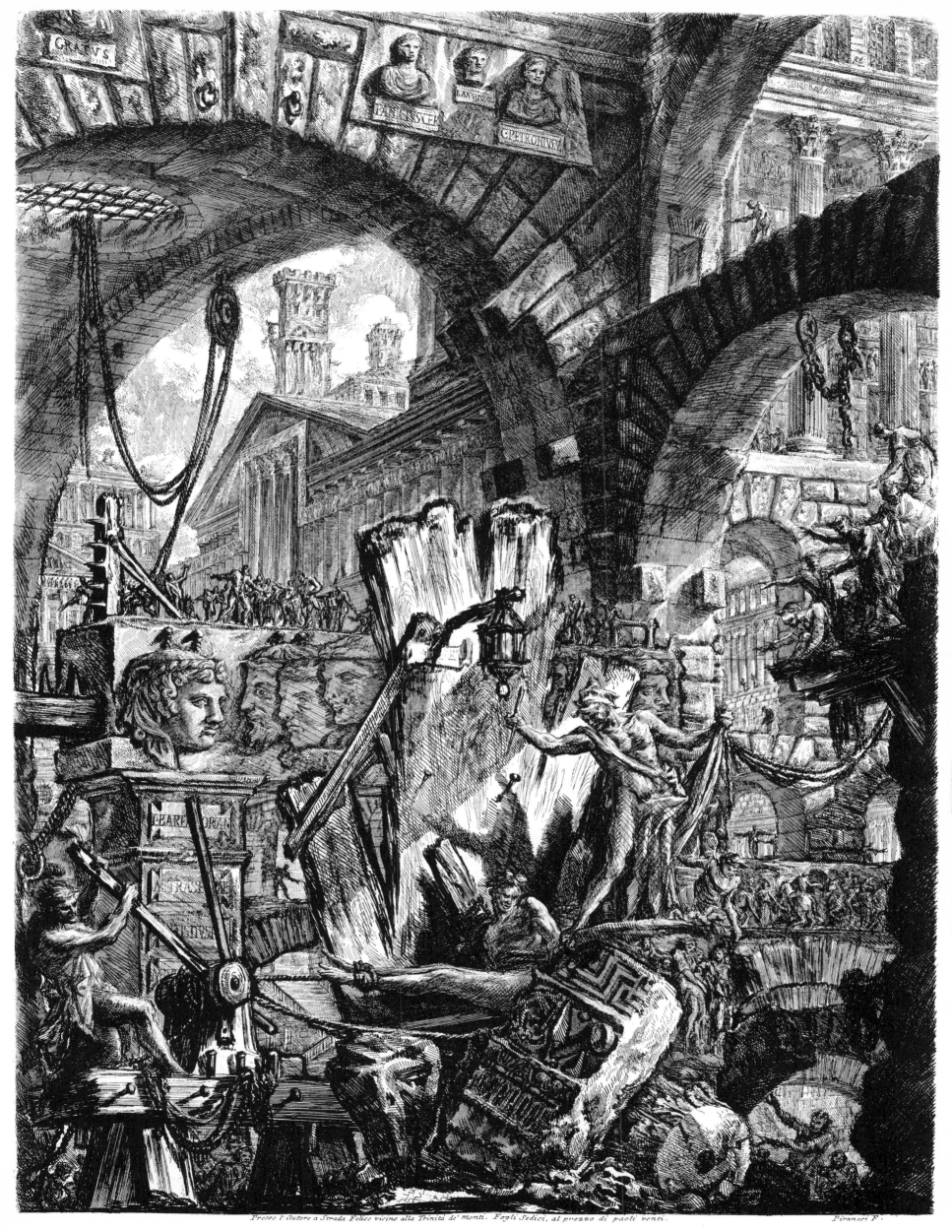

Presso l'Autore a Strada Felice vicino alla Trinità de' Monti. Fogli Sedici, al prezzo di paoli venti. Piranesi F.

Second State.

III

Carcere, with a Circular Tower.

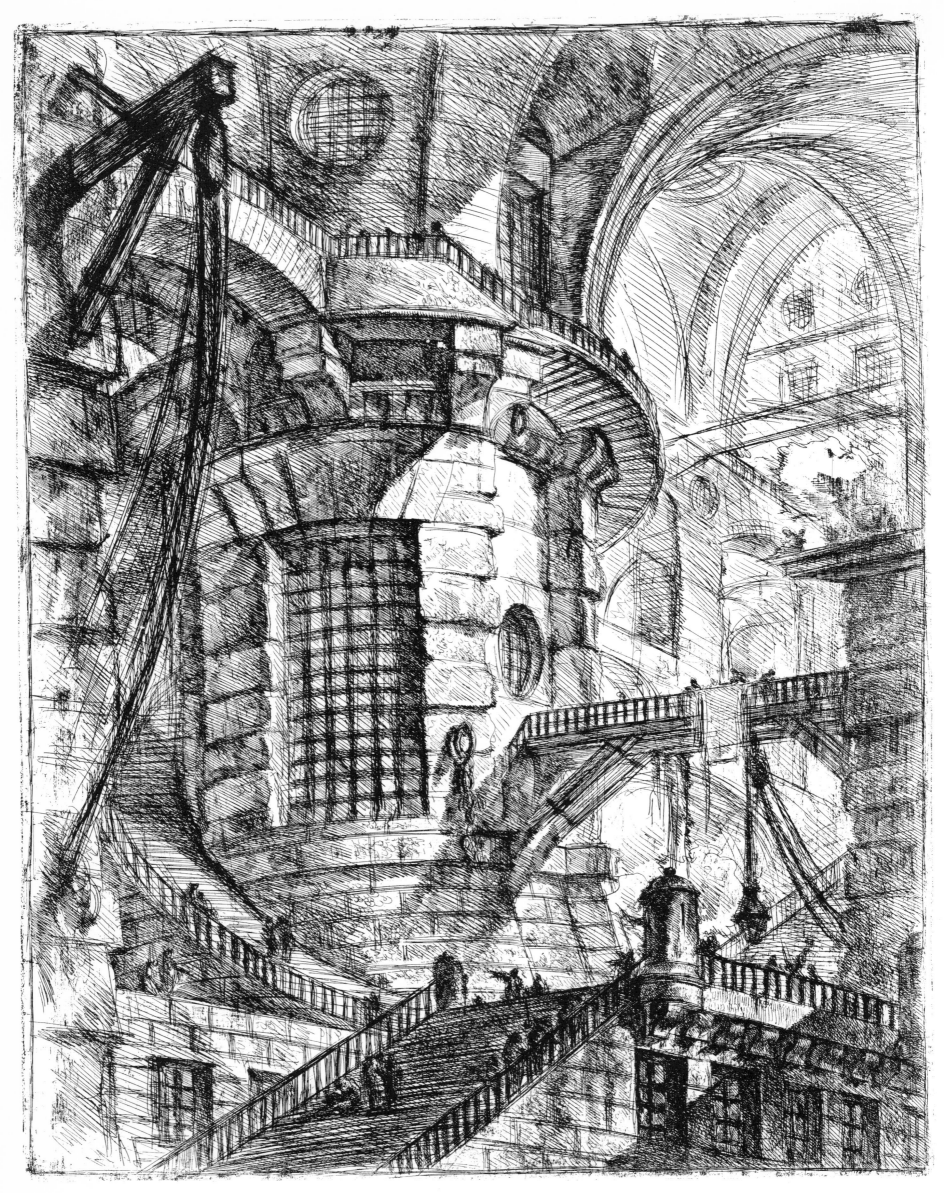

First State.

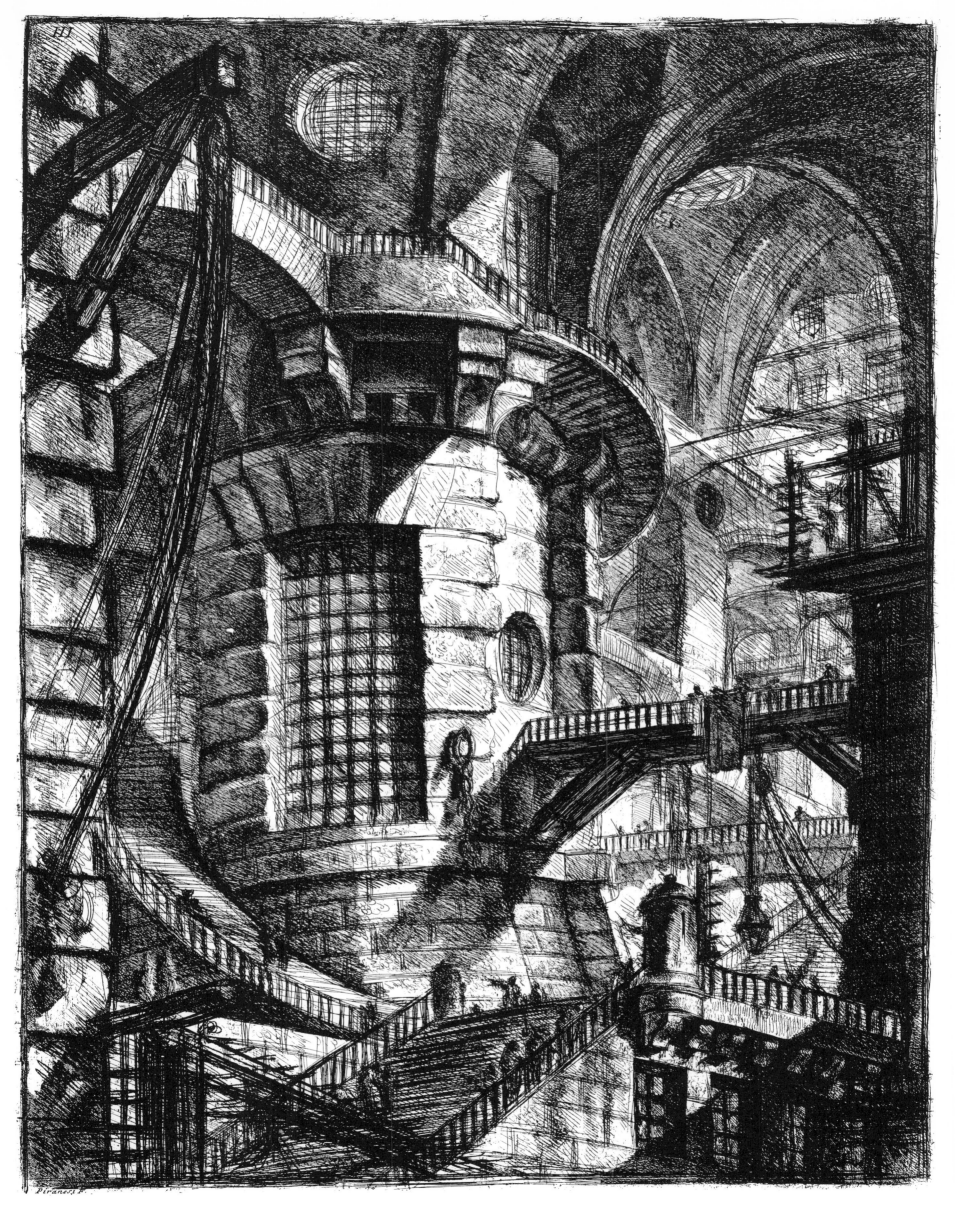

Second State.

IV

Carcere, with a View Through an Arch Toward a Bridge with a Sculptured Frieze.
Below, a Colonnade Reminiscent of St. Peter's Square in Rome.

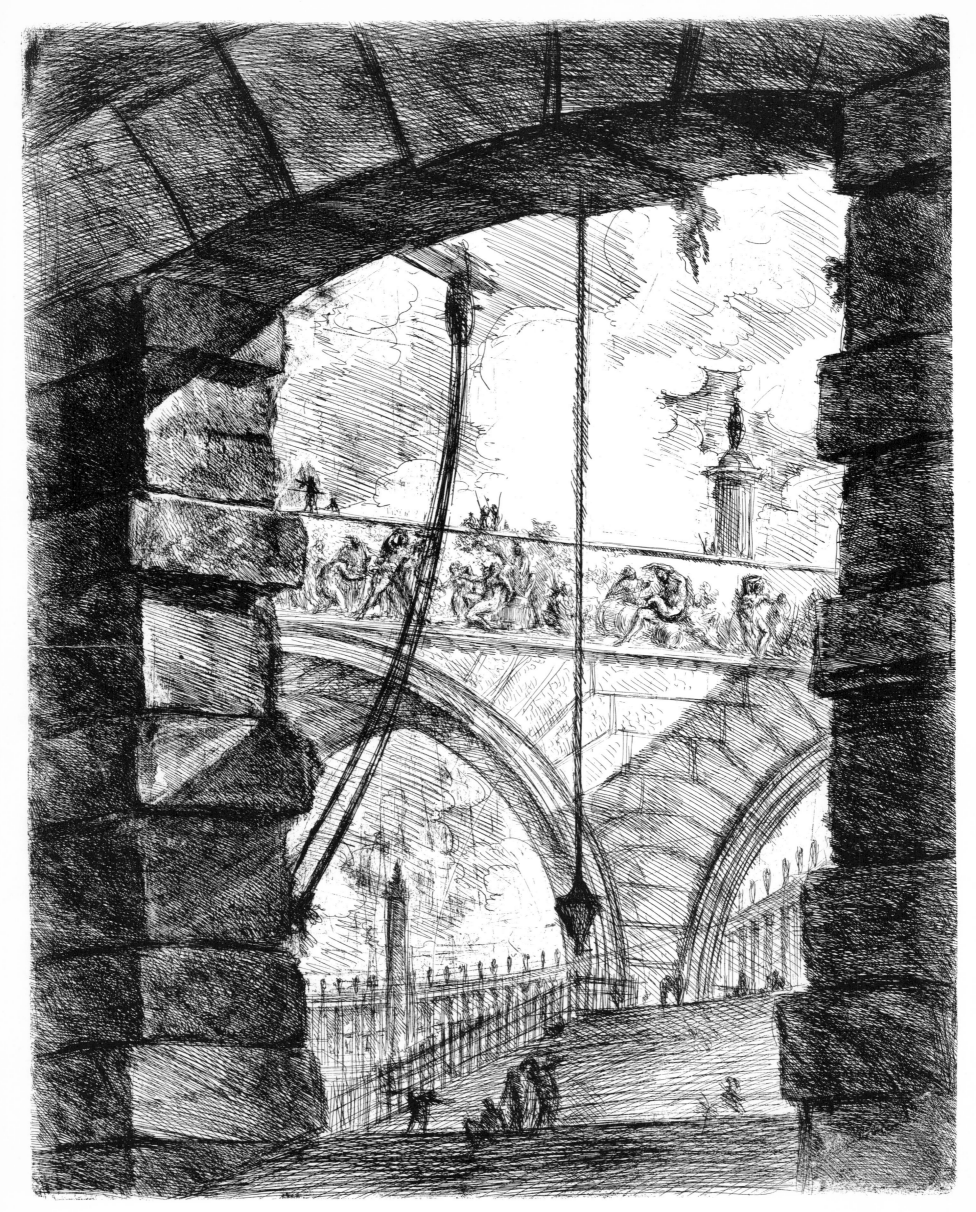

First State.

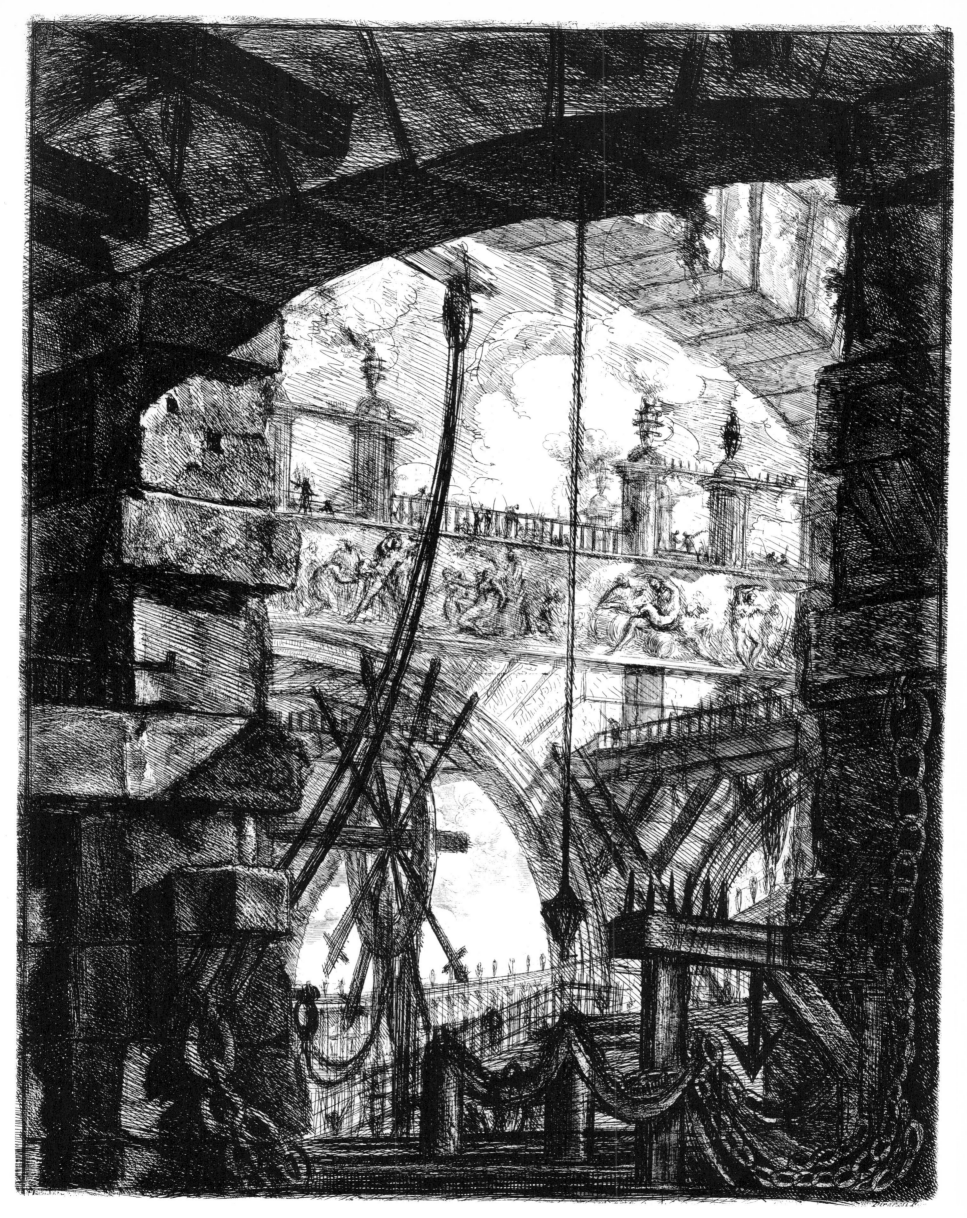

Second State

V

Carcere, like Plate II, with Similar Elaborate Paraphernalia.

No first-state version exists for Plate V.

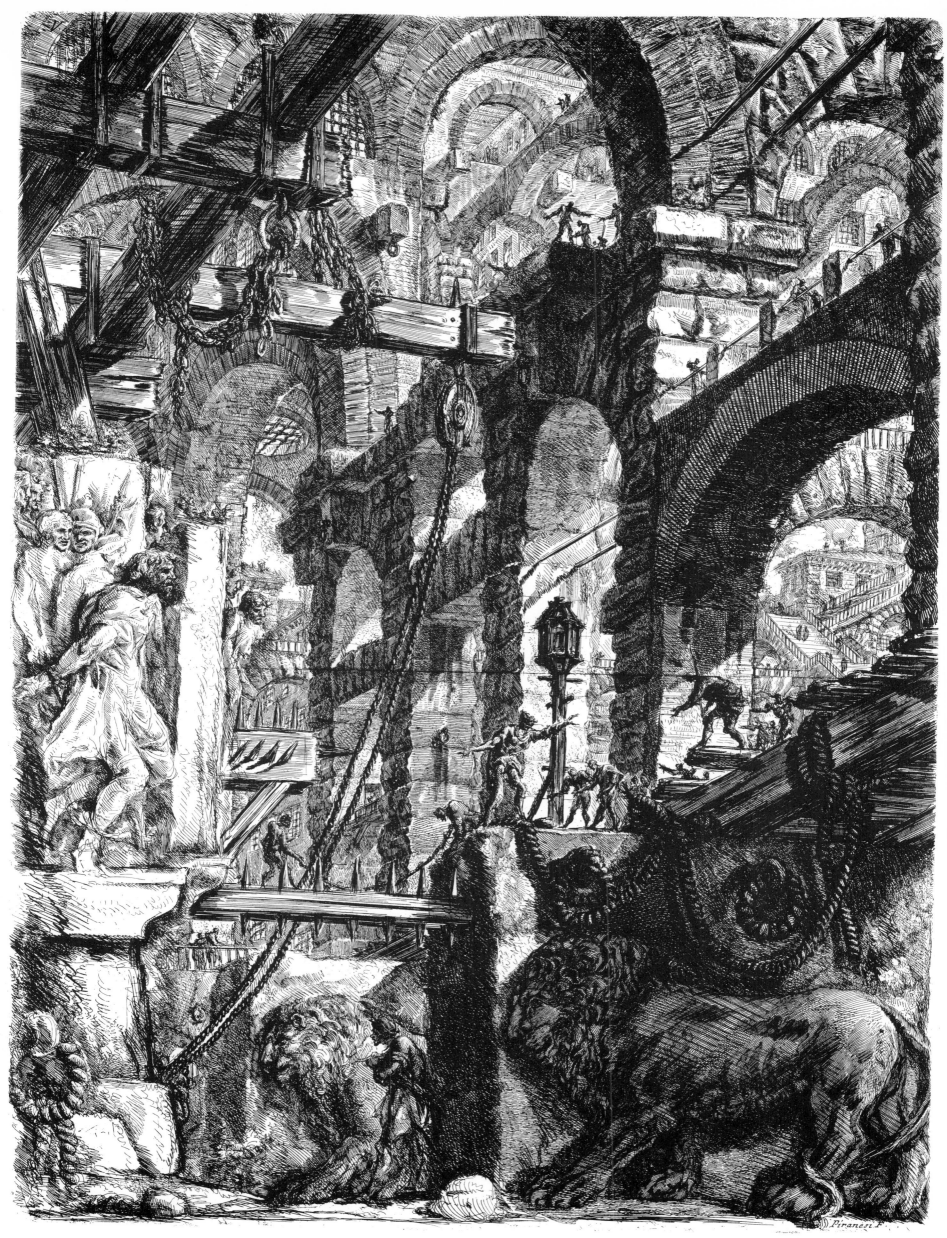

Second State

VI

Carcere, with Arches and Pulleys and a Smoking Fire in the Center.

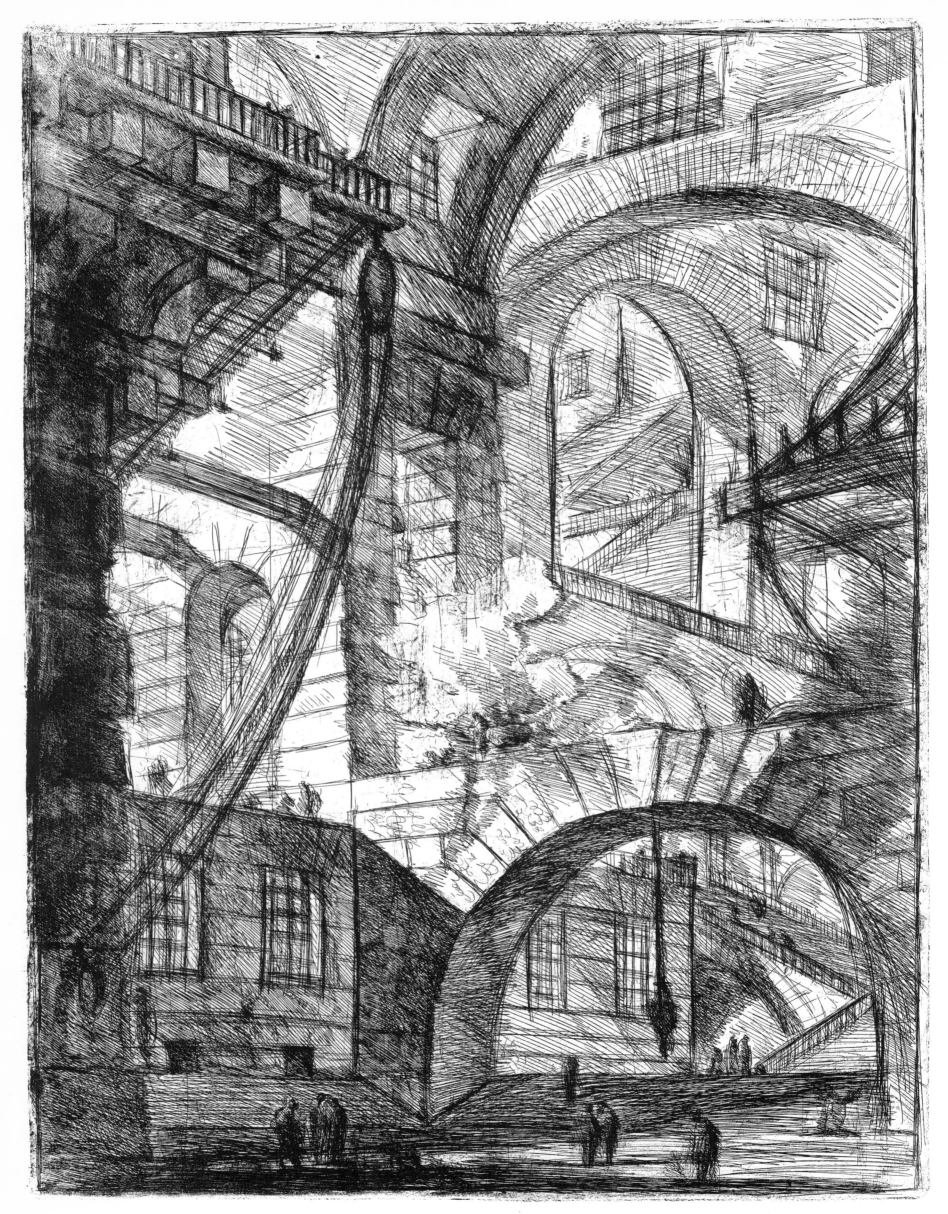

First State.

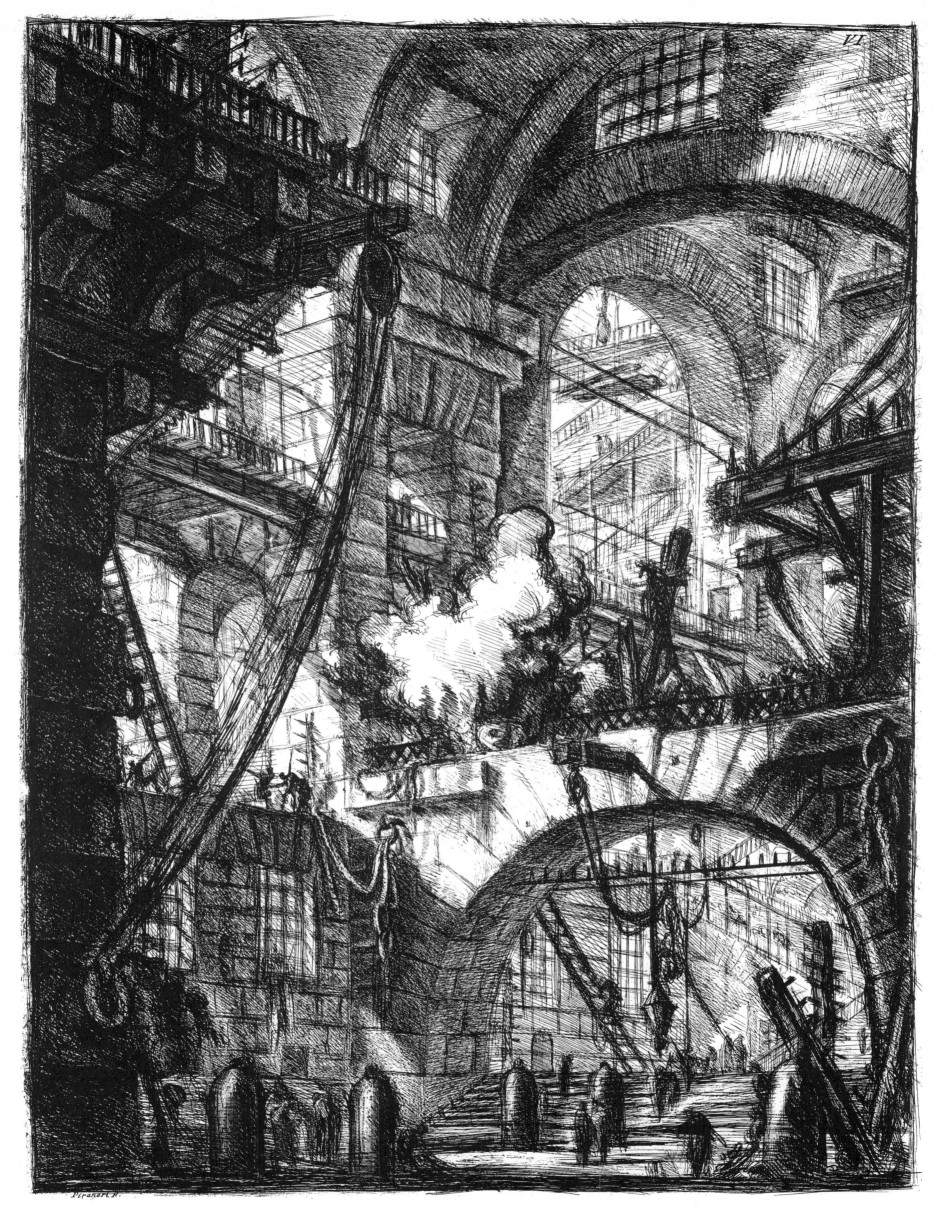

Second State

VII

Carcere, with Numerous Wooden Galleries and a Drawbridge.

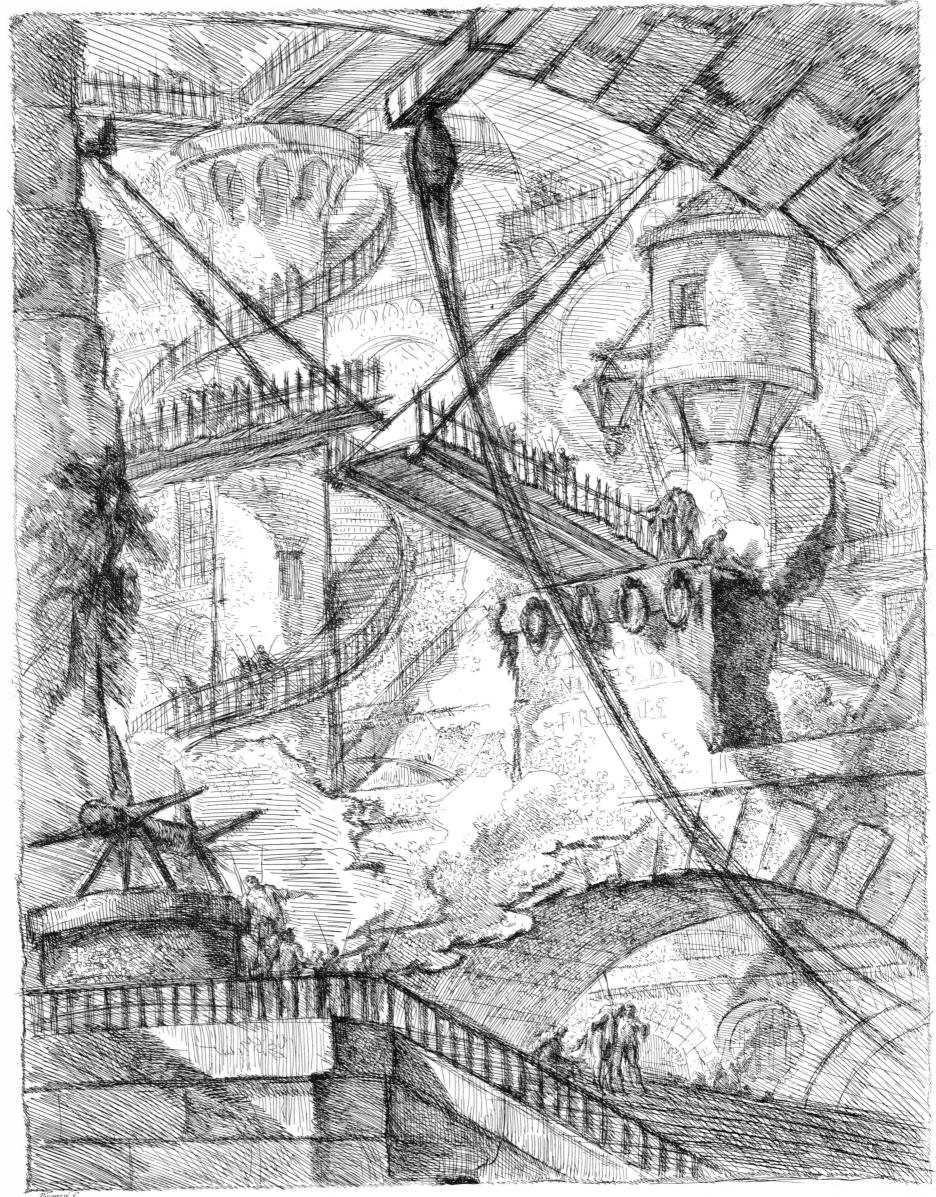

Piranesi f.

First State.

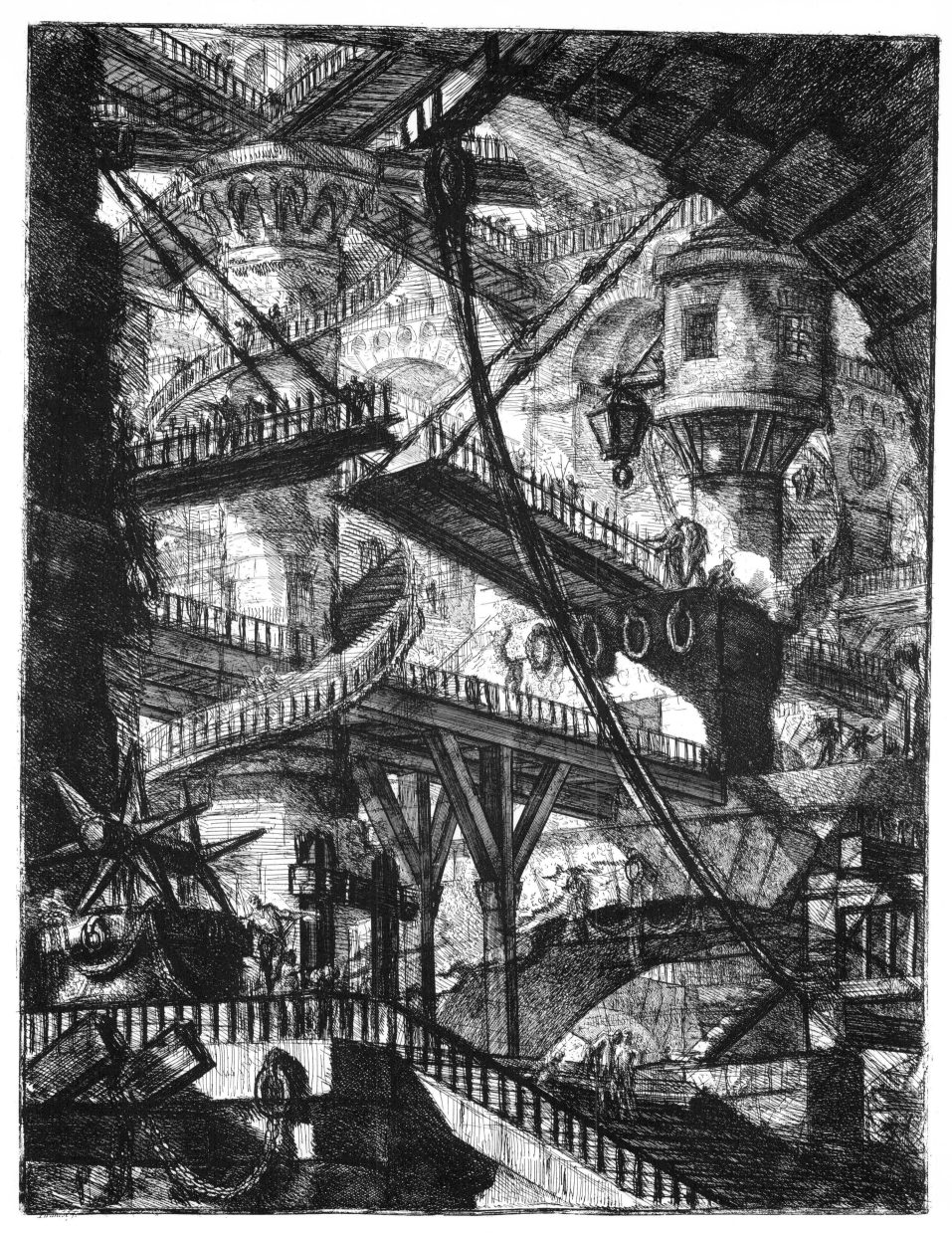

Second State.

VIII

Carcere, with a Staircase Flanked by Military Trophies.

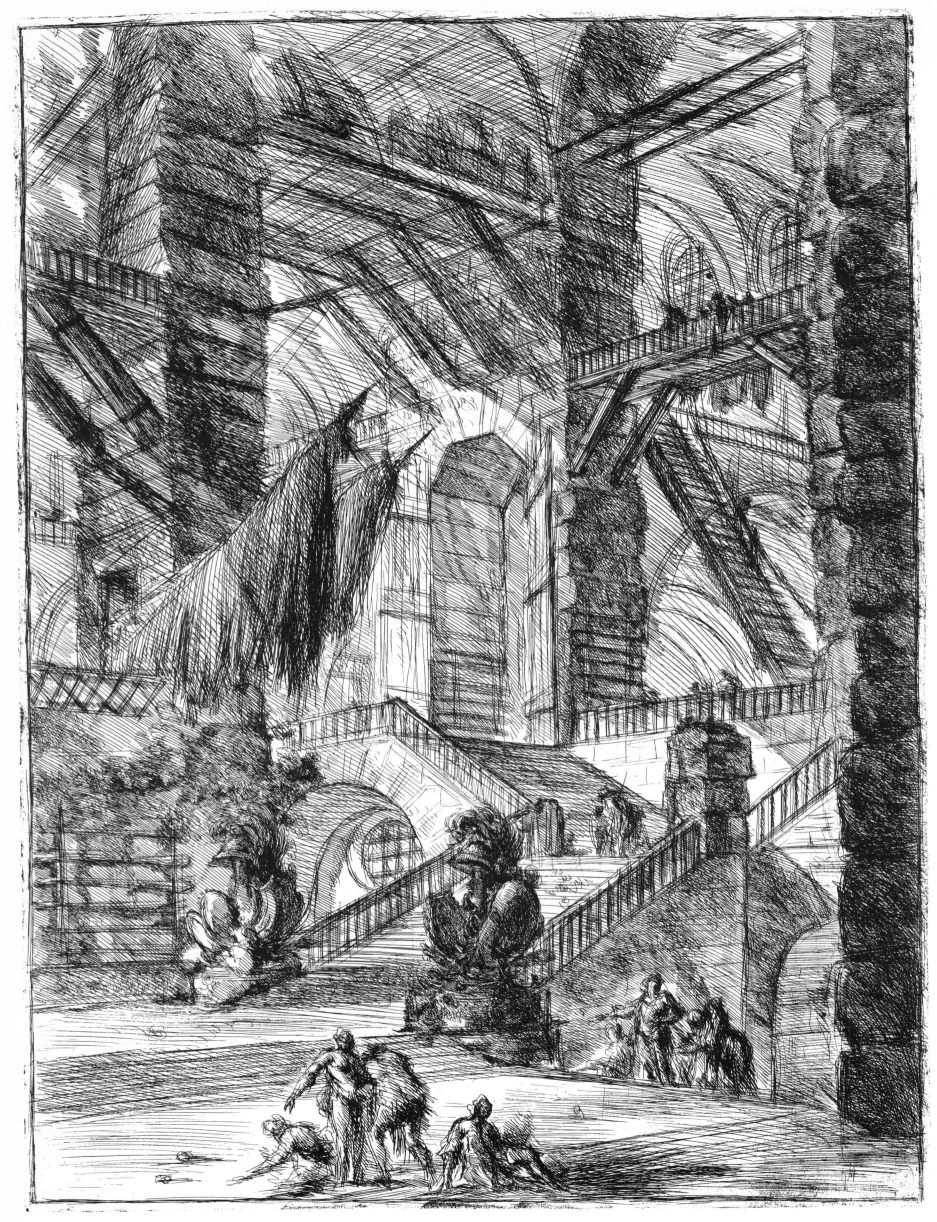

First State.

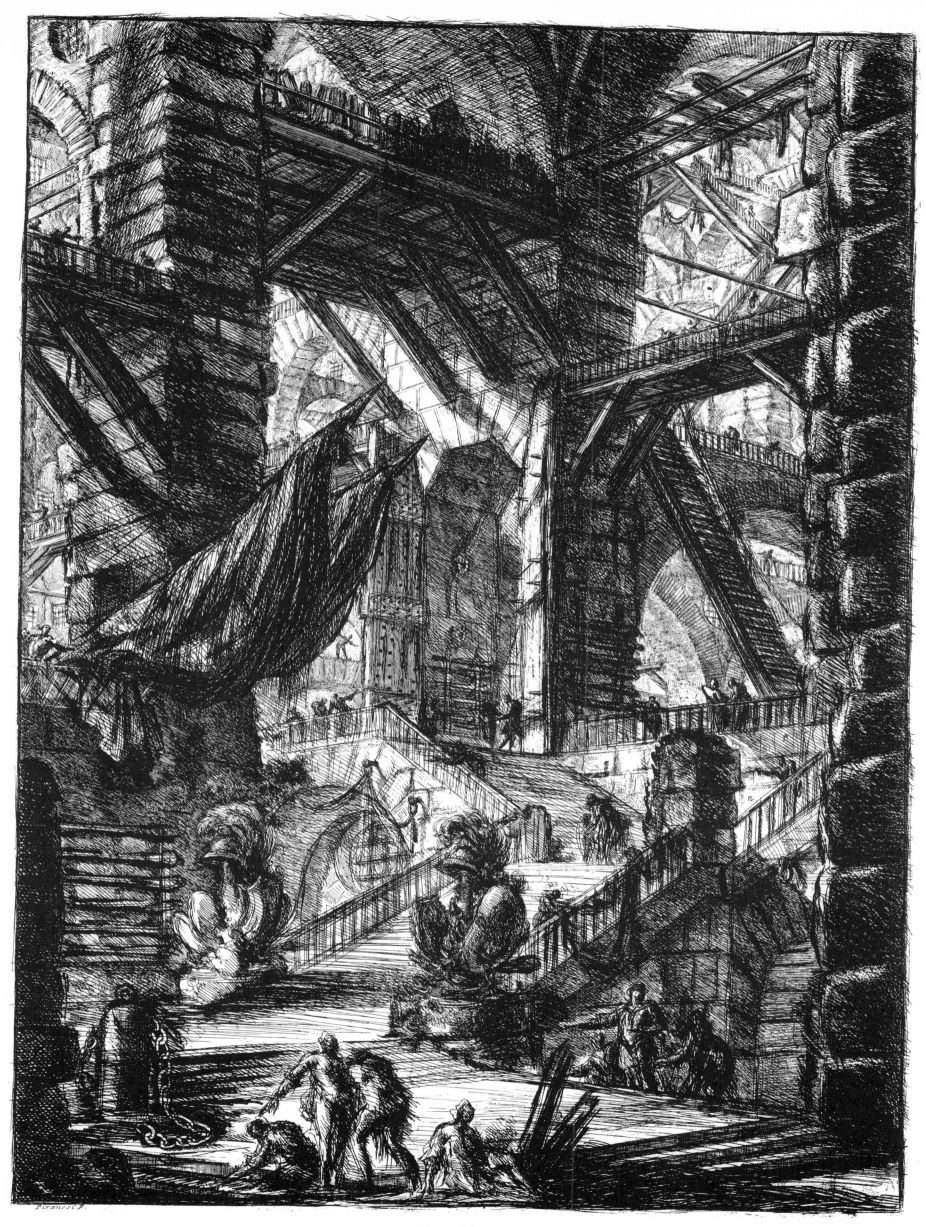

Second State.

IX

Carcere, with a Doorway Surmounted by a Colossal Wheel-shaped Opening.

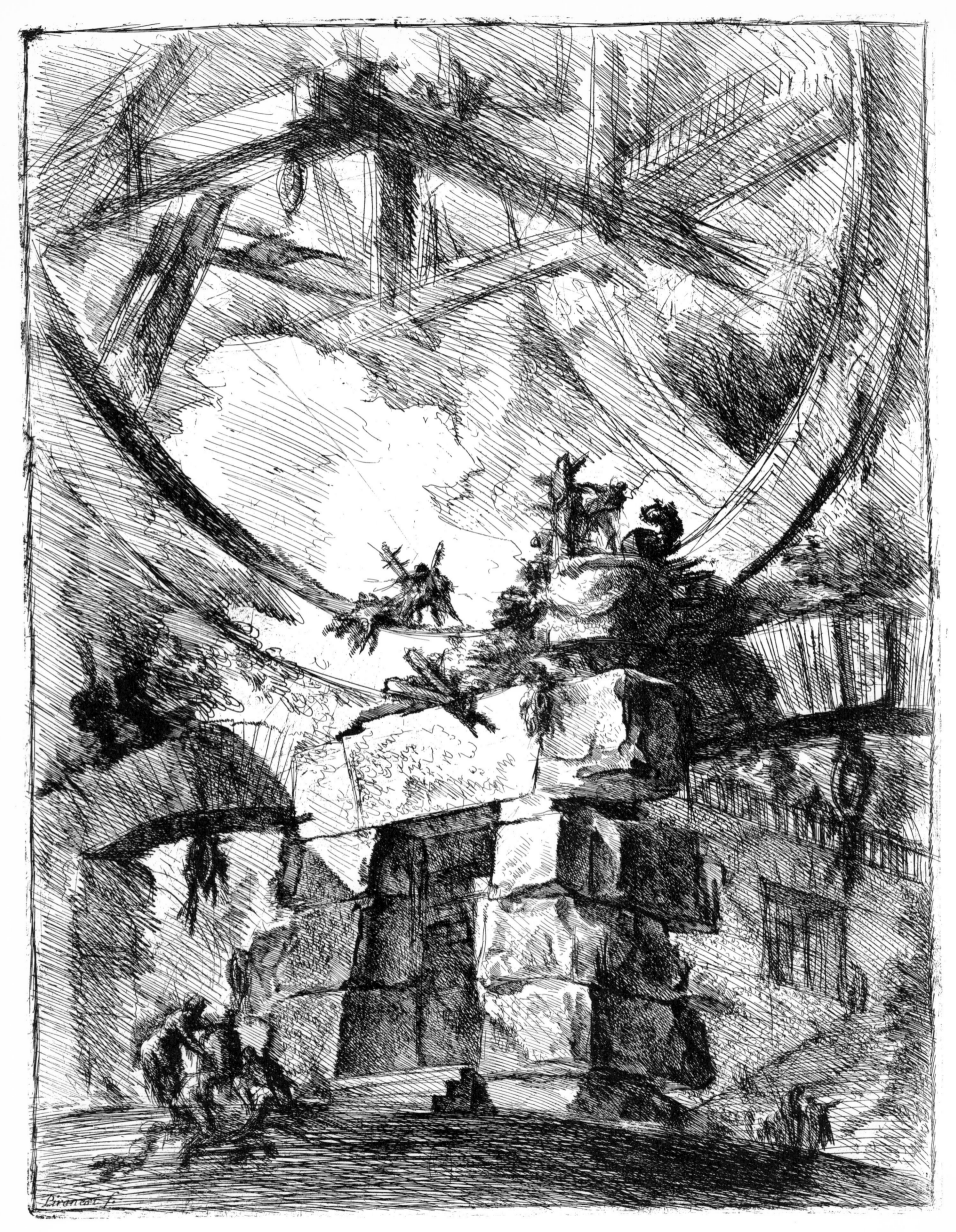

First State.

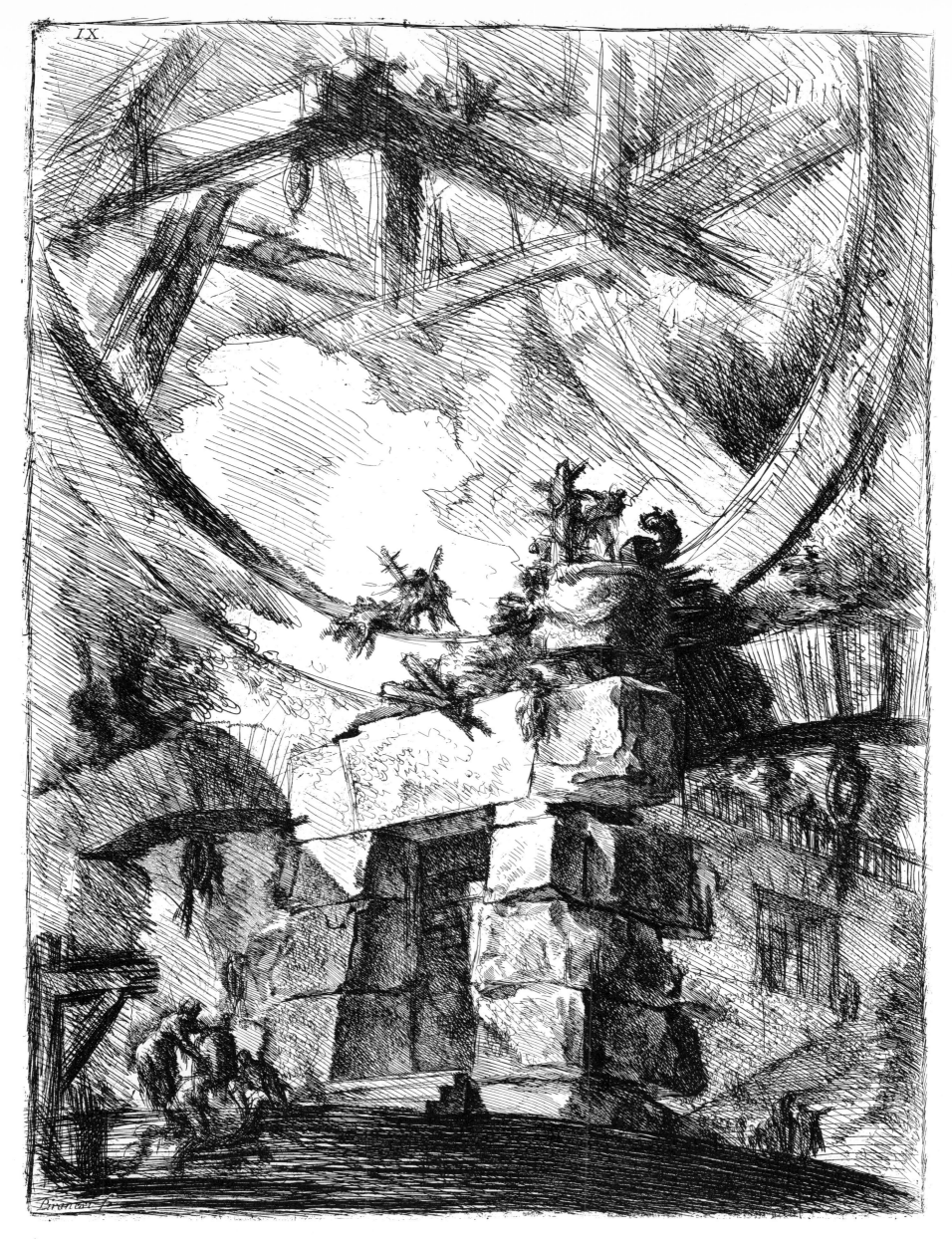

Second State.

X

Carcere, with a Group of Captives Chained to Posts.

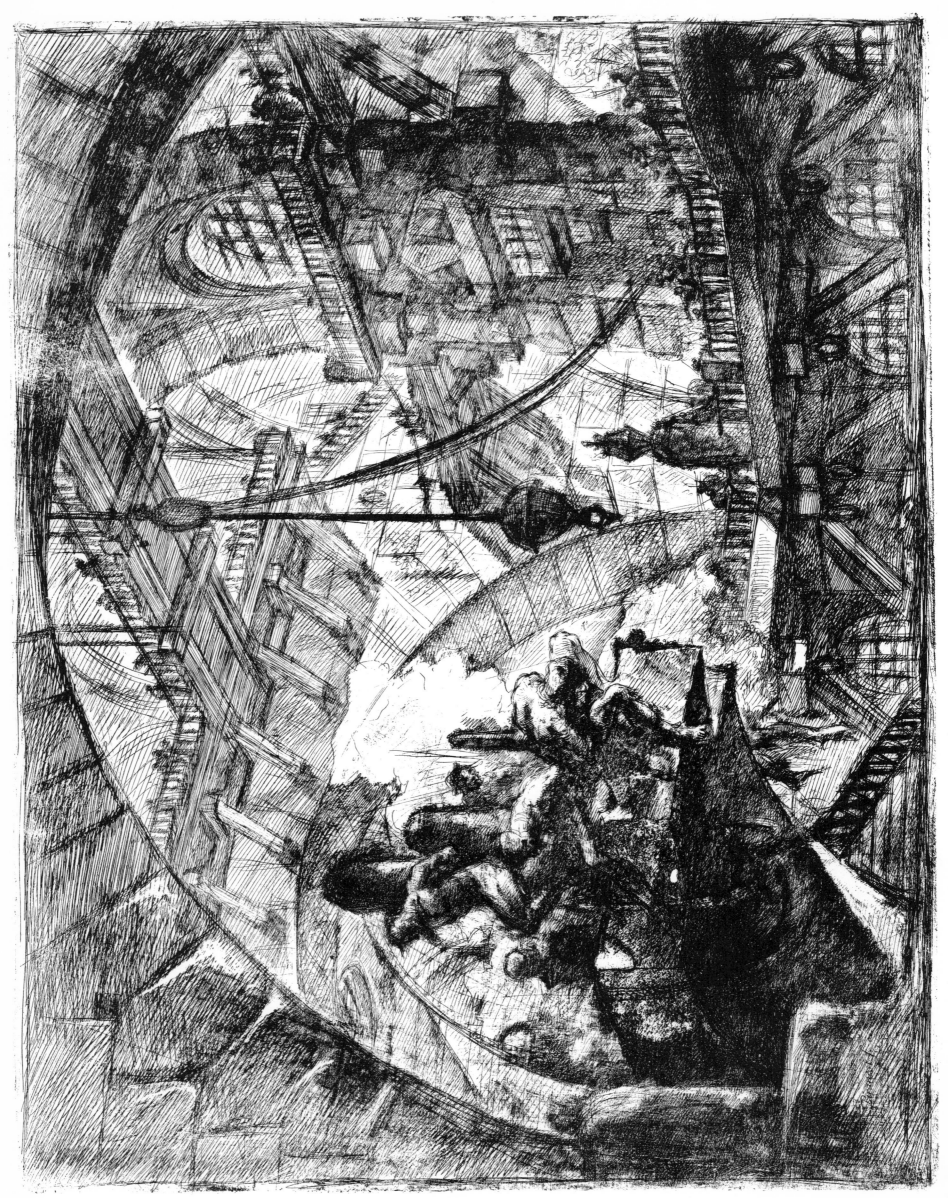

First State.

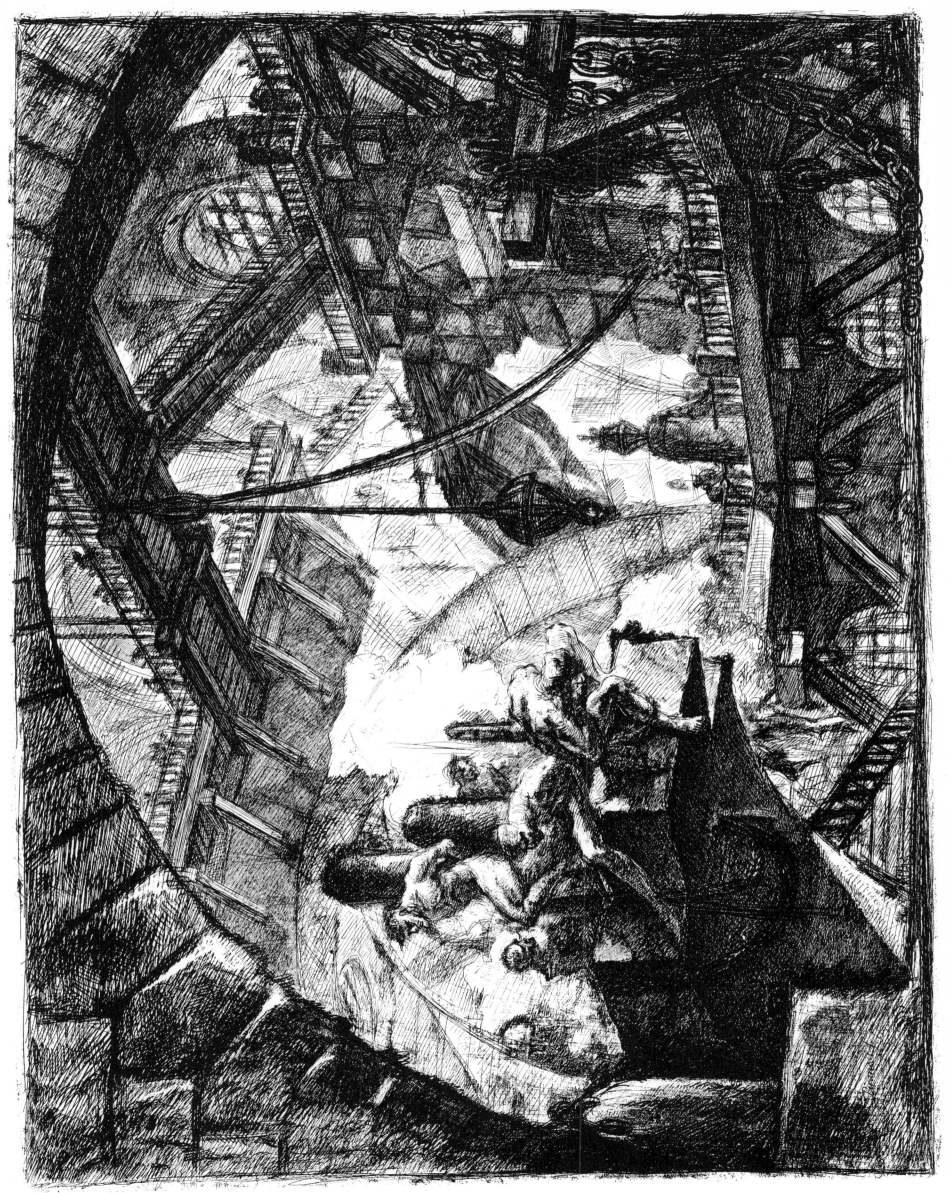

XI

Carcere, with a Central Hanging Lantern.

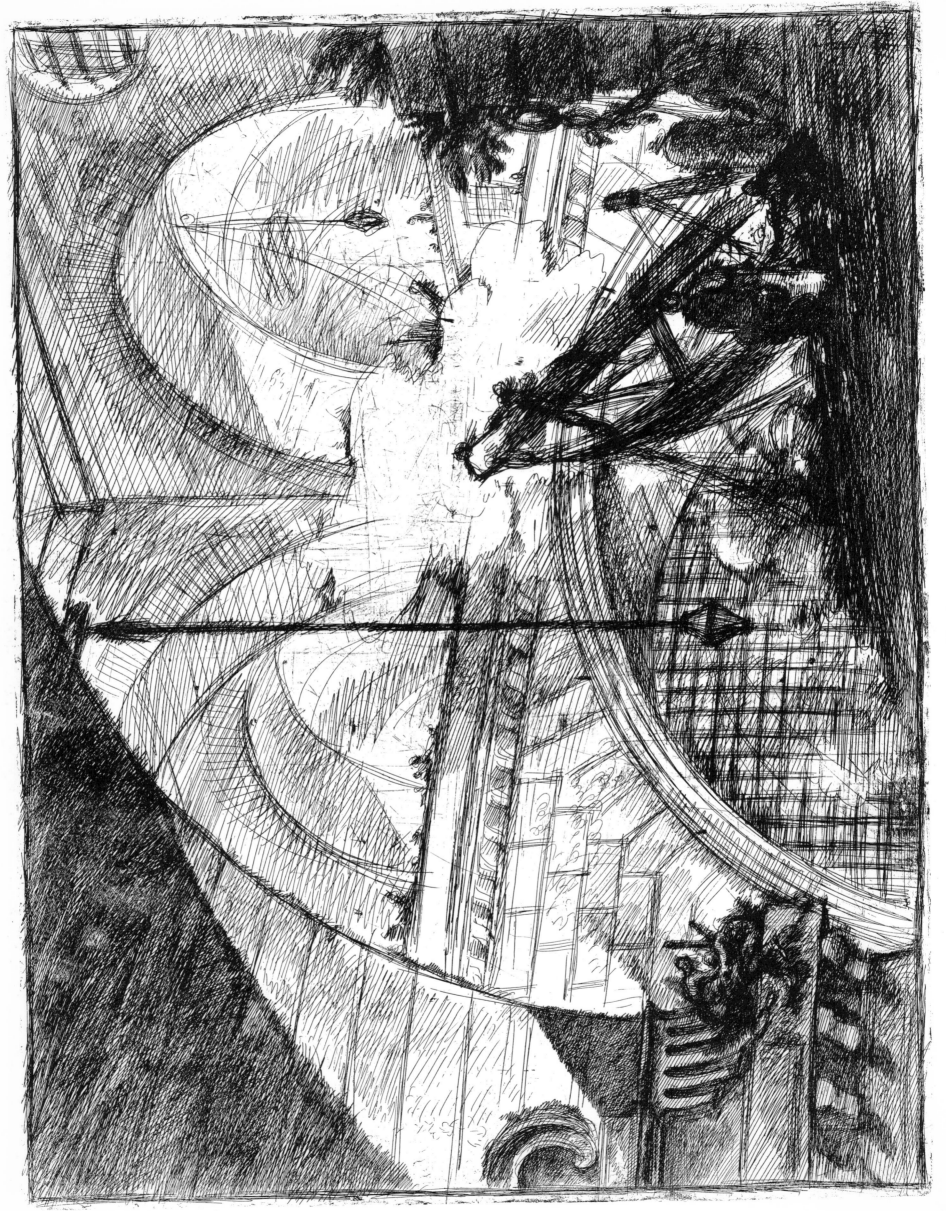

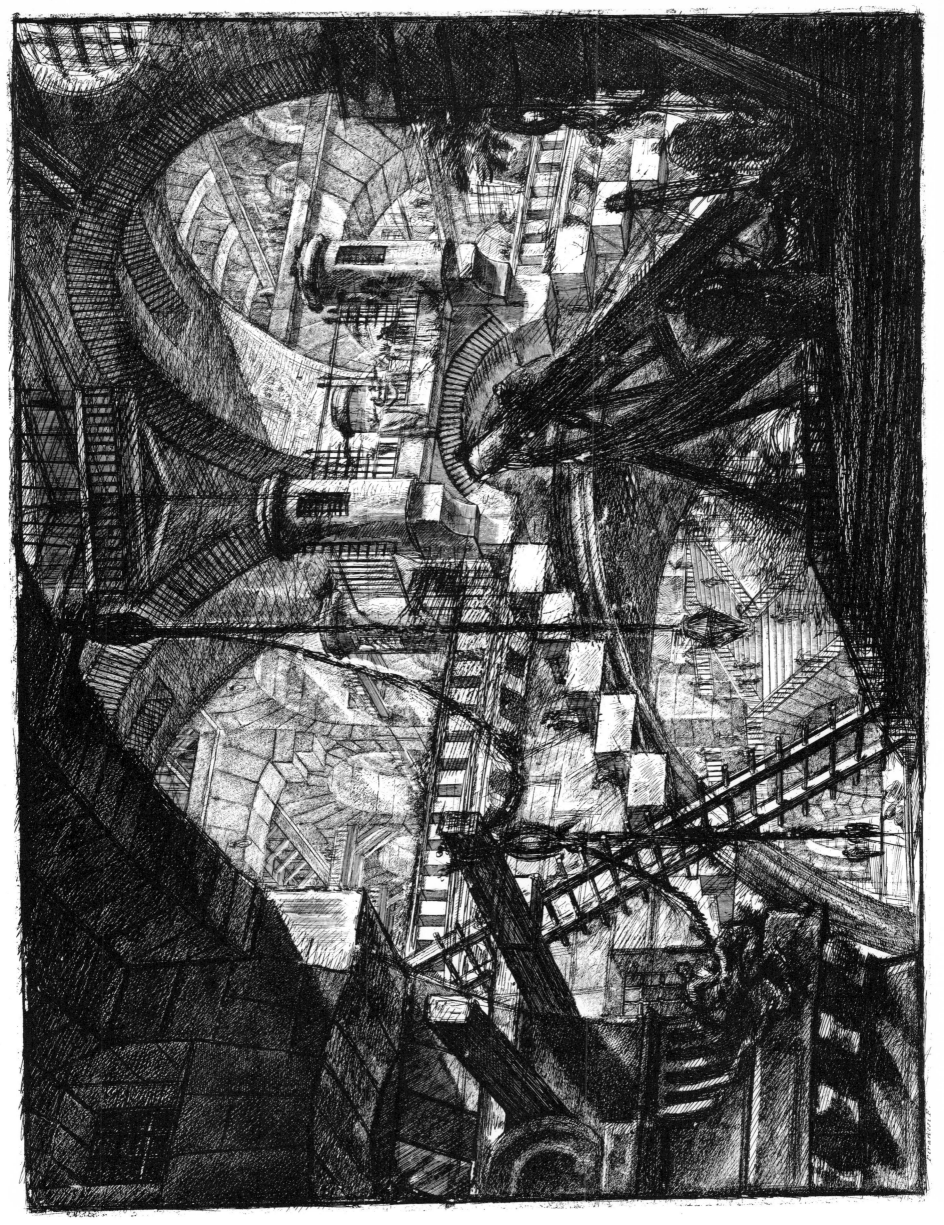

Second State

XII

Carcere, with a Platform Approached by Steps.

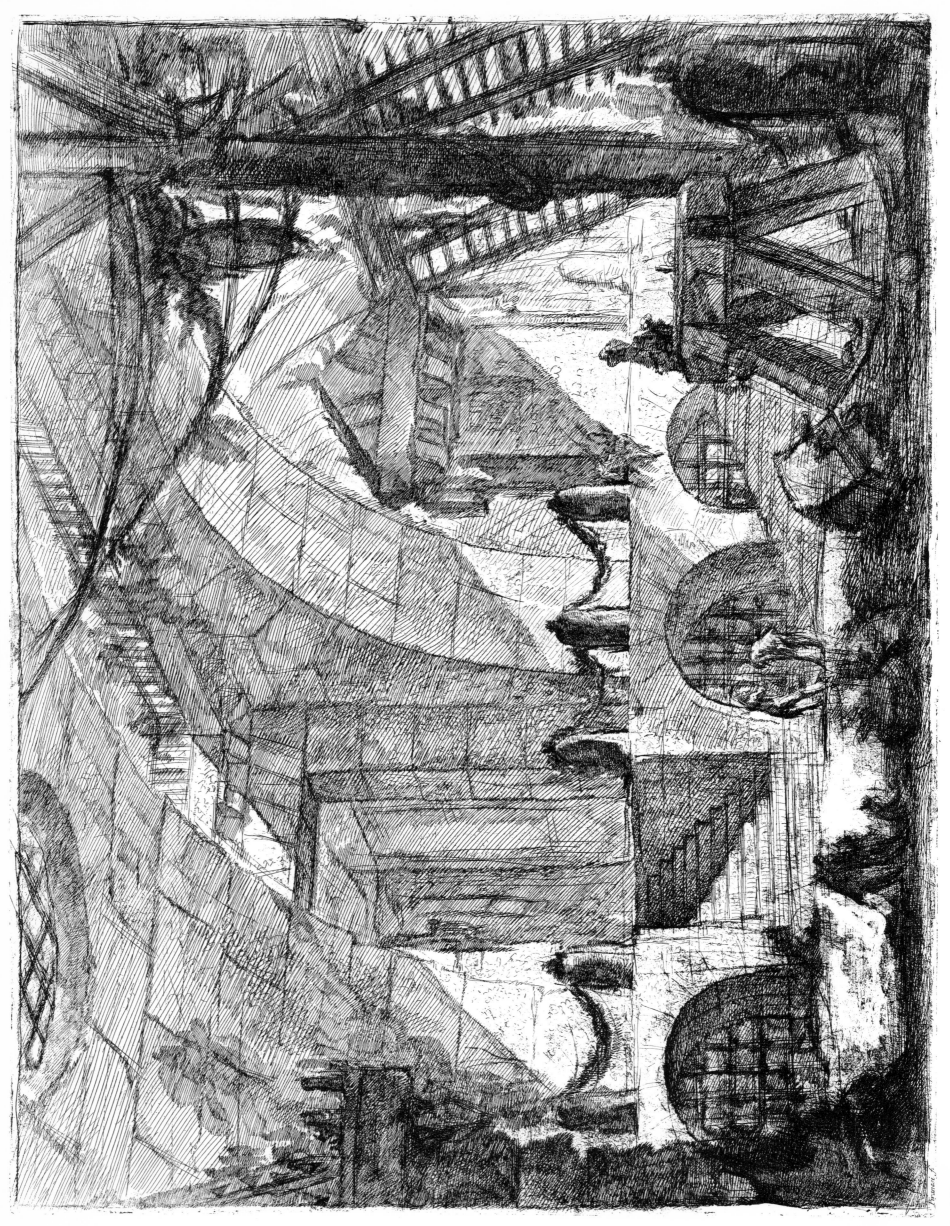

First State.

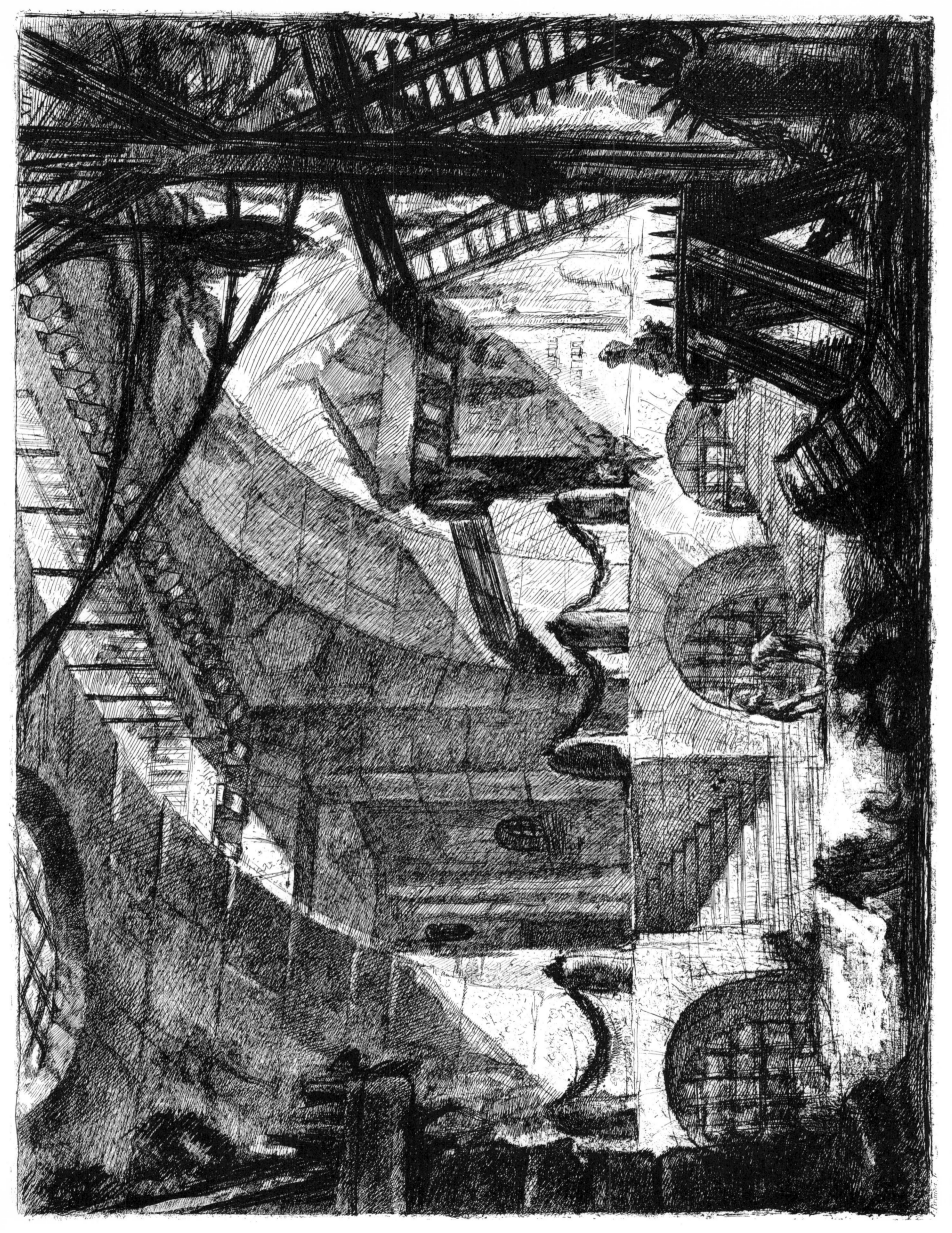

Second State

XIII

Carcere, with Several Straight, Broad Central Staircases.

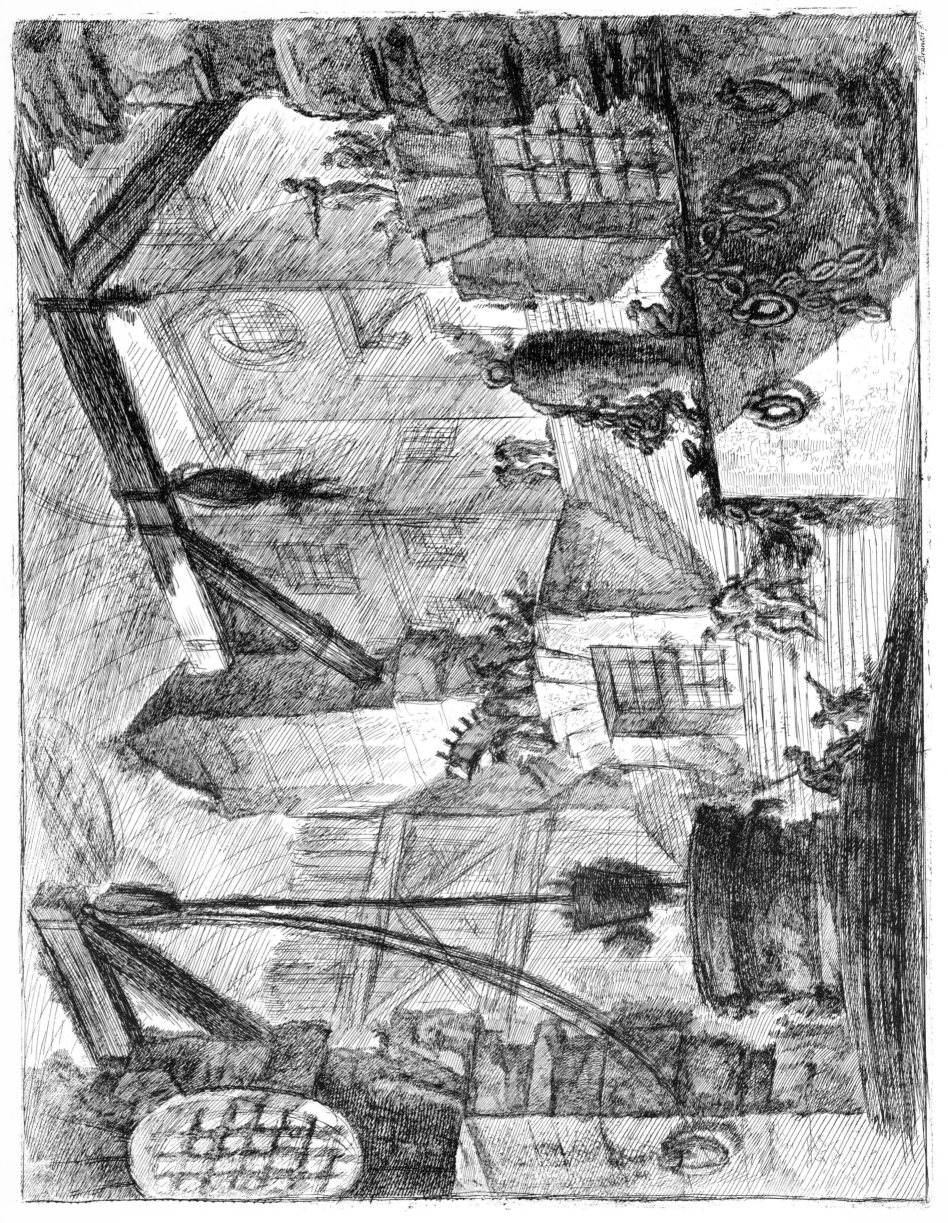

First State.

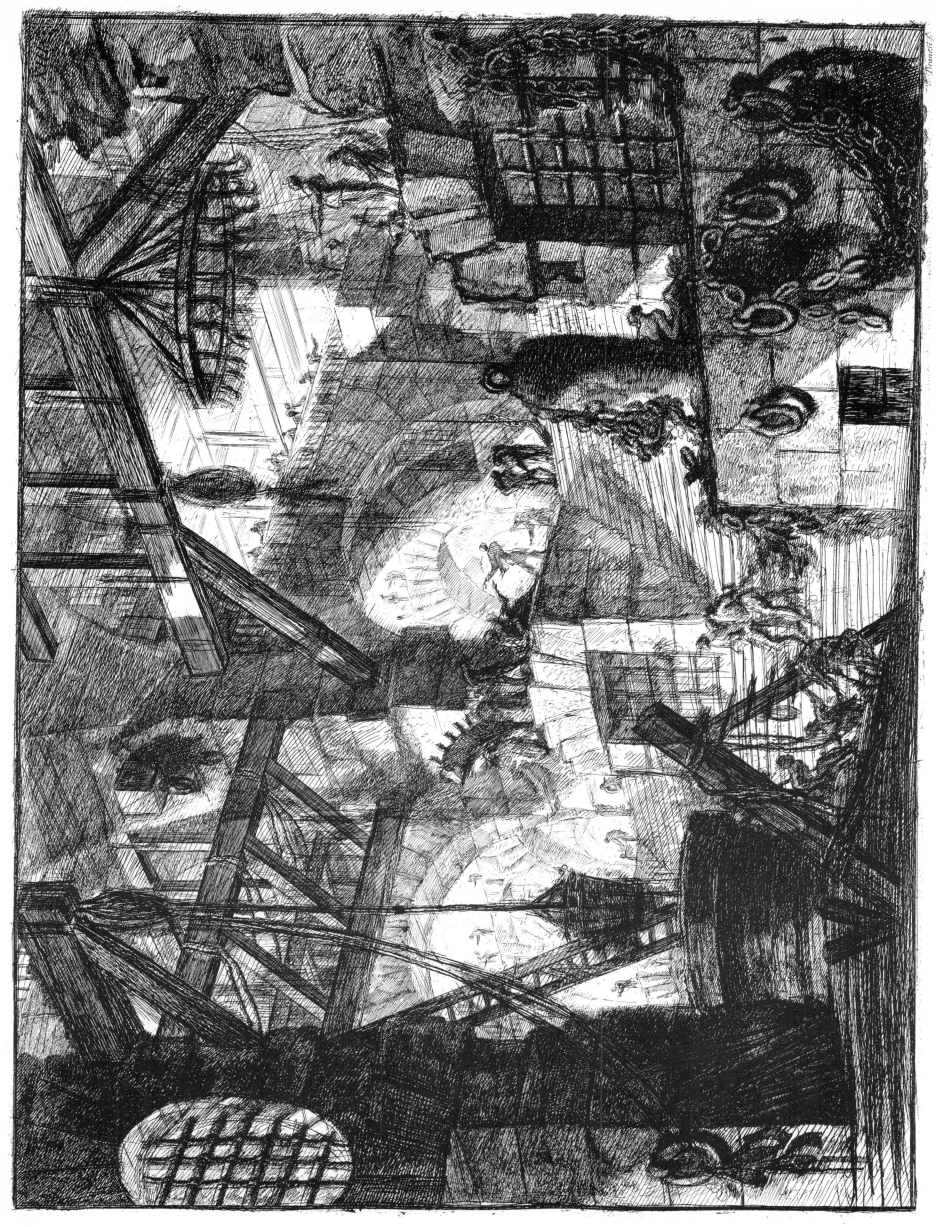

Second State

XIV

Carcere, with a Staircase Ascending to the Left.

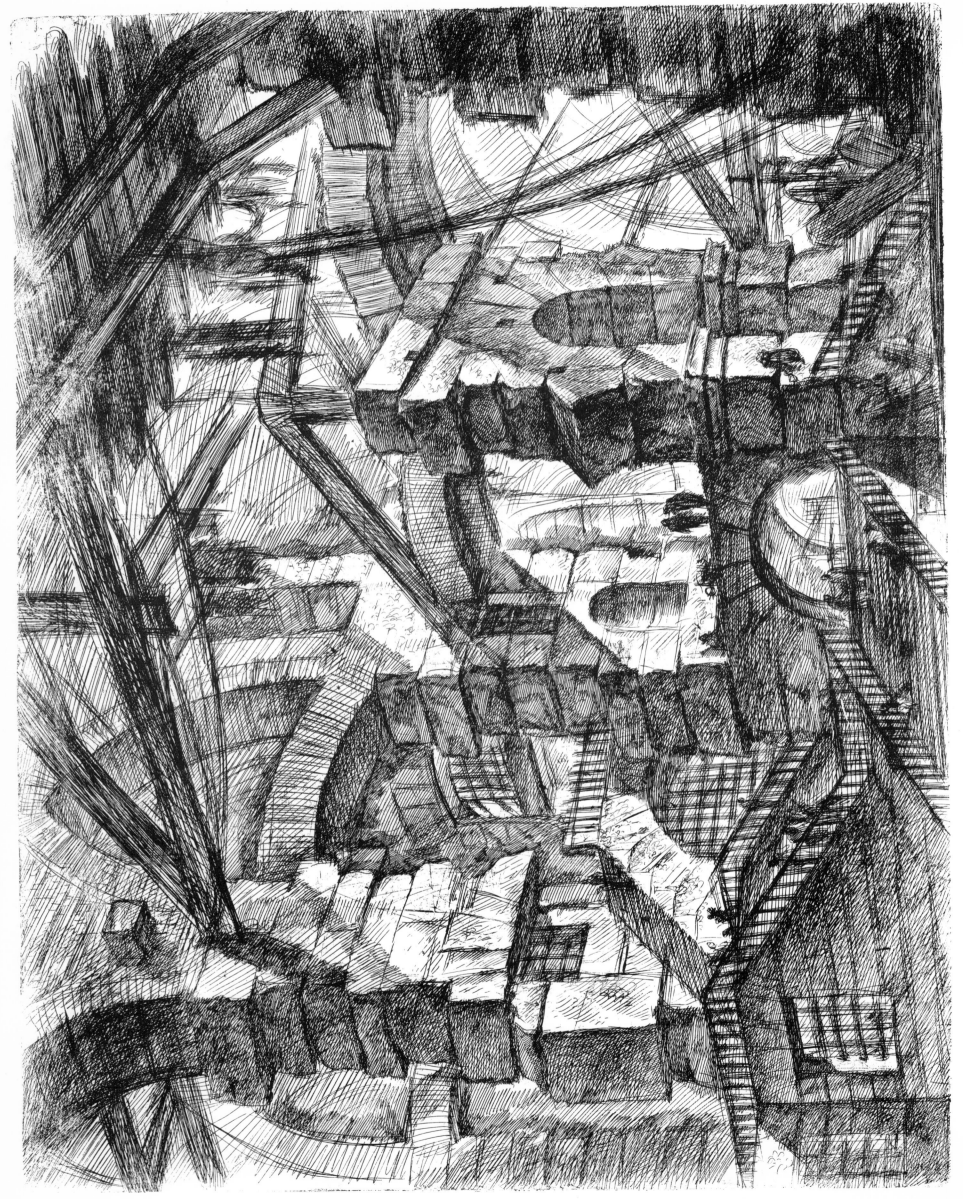

First State.

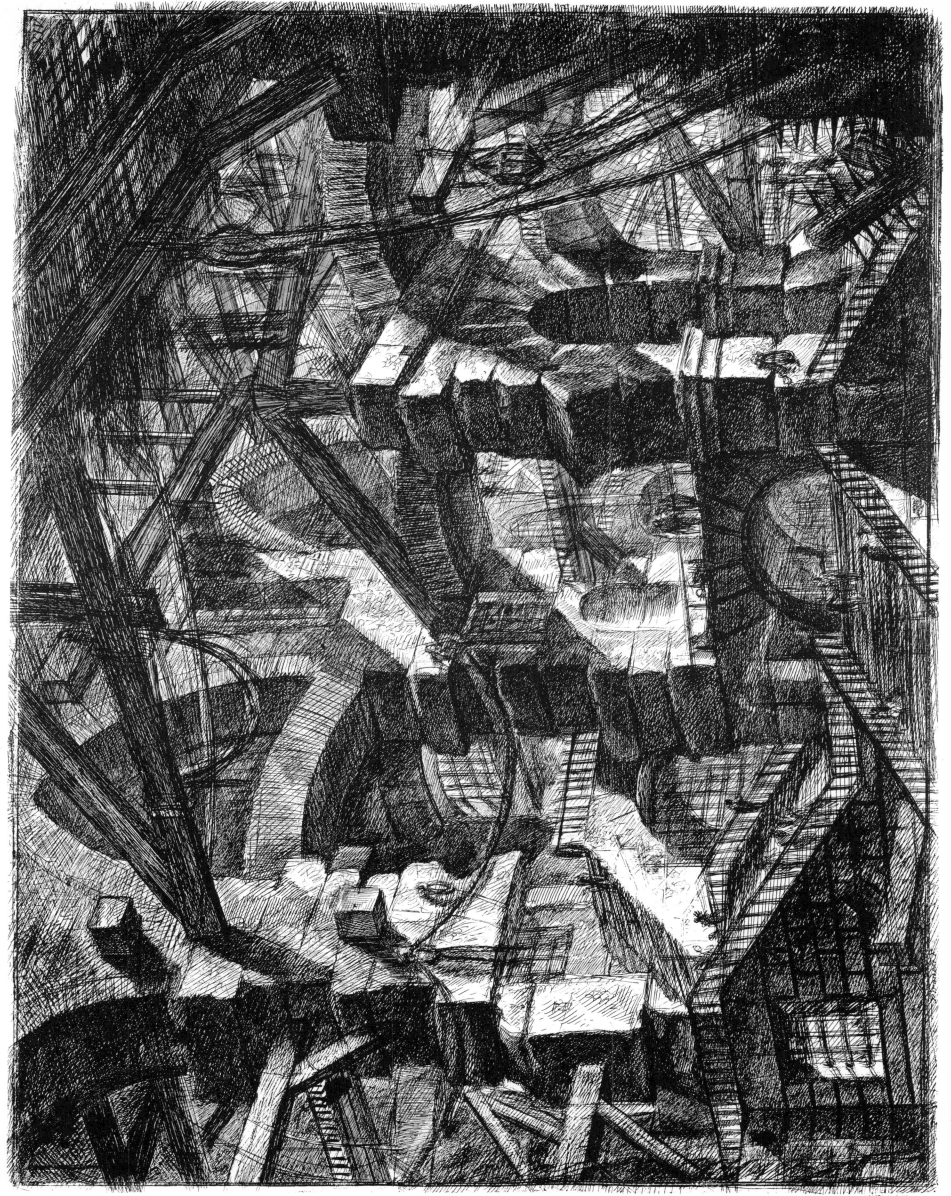

Second State.

XV

Carcere, with Vaults Springing from a Monumental Pier.

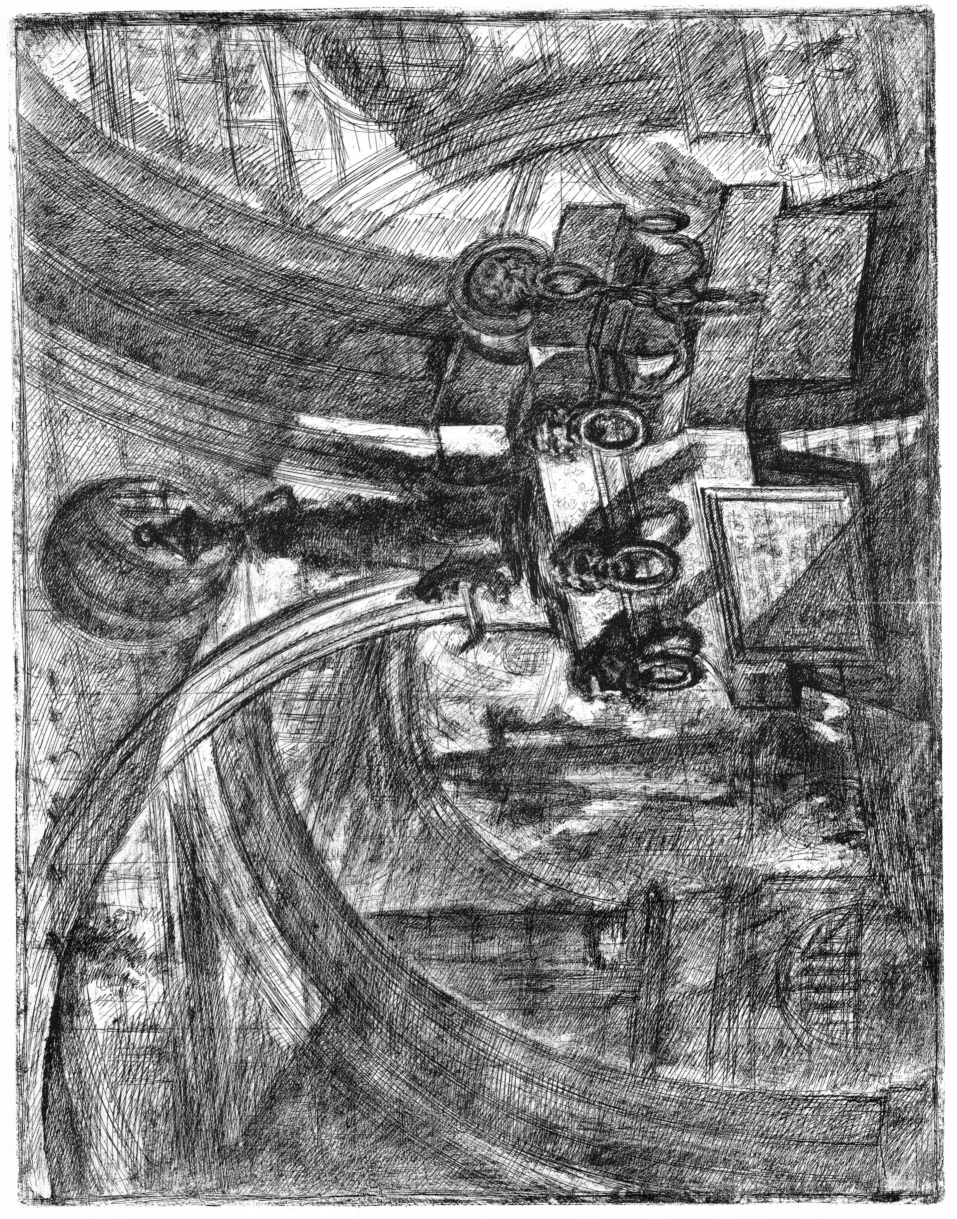

First State.

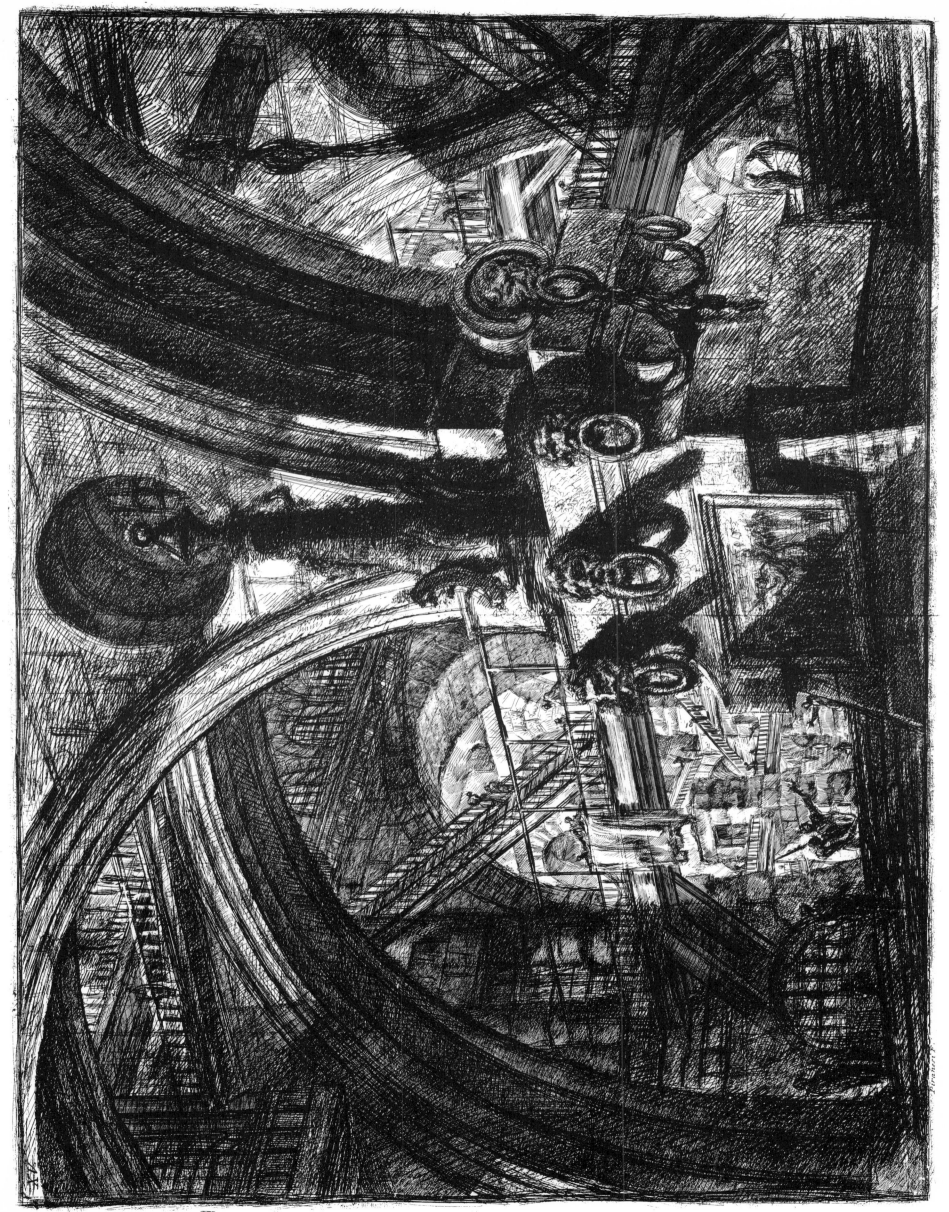

Second State.

XVI

Carcere, with a High Gallery Beyond a Low, Timbered Anteroom.

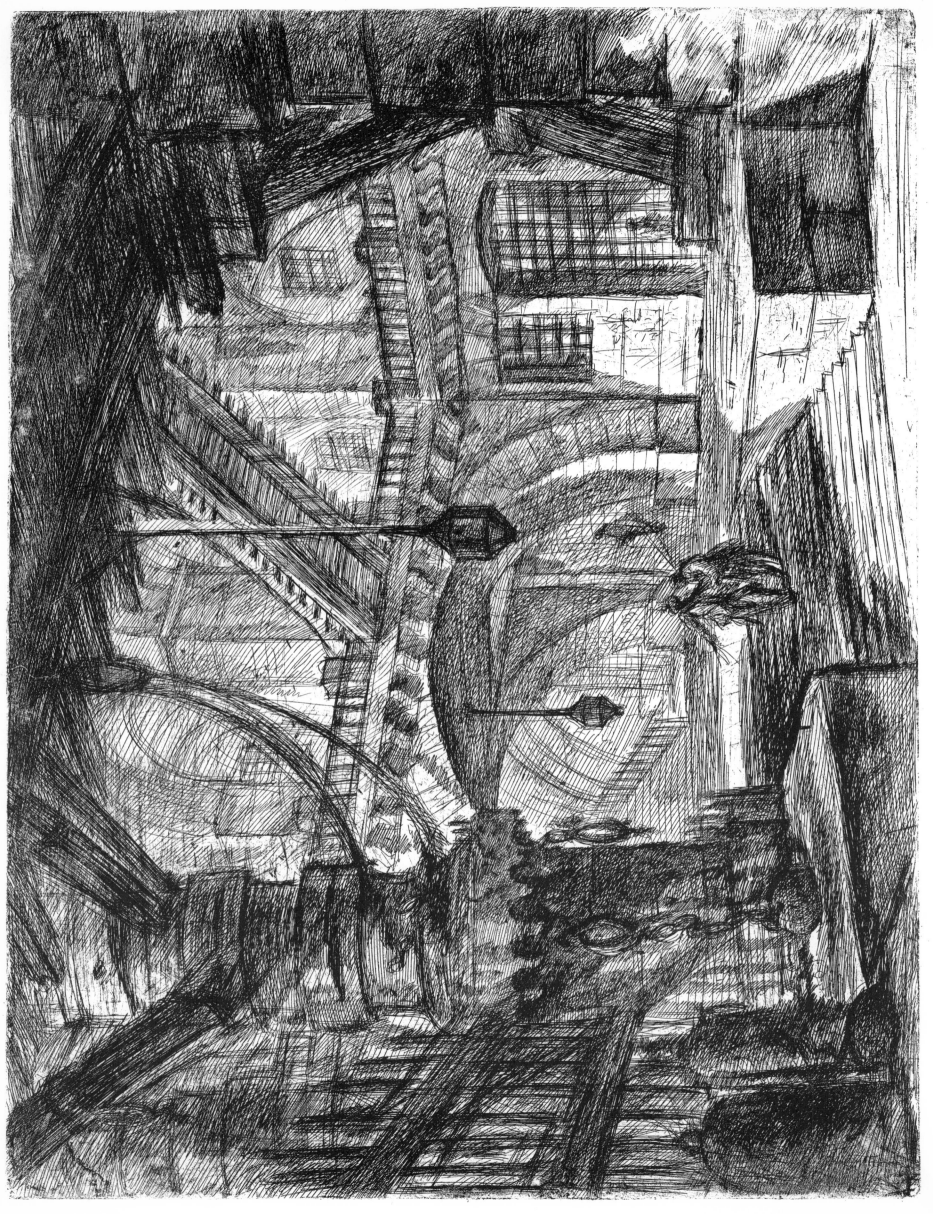

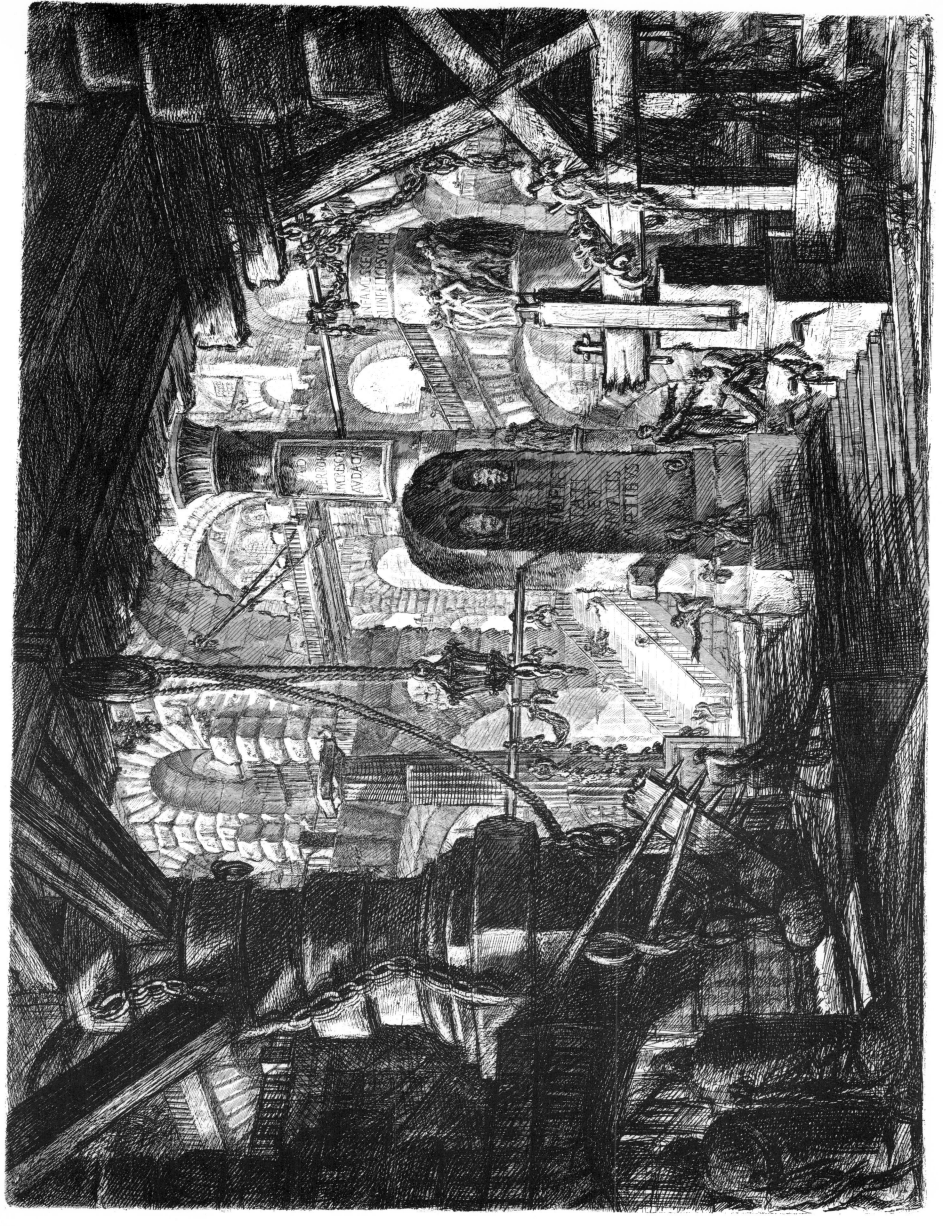

Second State.